VOICES OF AMERICA

Golden Memories of the

SAN FRANCISCO BAY AREA

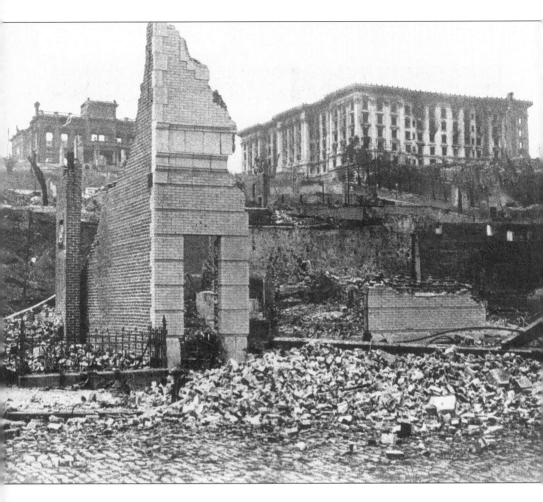

San Francisco's water mains were severed as a result of the April 18, 1906 earthquake and fire. Small fires rapidly grew into towering infernos and much of the city was destroyed within three days. Many neighborhoods, like Nob Hill, were completely destroyed. It is considered one of the greatest natural disasters to befall an American city.

VOICES OF AMERICA

Golden Memories of the

SAN FRANCISCO BAY AREA

Compiled and edited by
STEVEN FRIEDMAN

ARCADIA

Published by Arcadia Publishing,
an imprint of Tempus Publishing, Inc.
2 Cumberland Street
Charleston, SC 29401

Printed in Great Britain.

Library of Congress Catalog Card Number: 00-100831

For all general information contact Arcadia Publishing at:
Telephone 843-853-2070
Fax 843-853-0044
E-Mail: sales@arcadiapublishing.com

For customer service and orders:
Toll-Free 1-888-313-2665

Visit us on the internet at http://www.arcadiapublishing.com

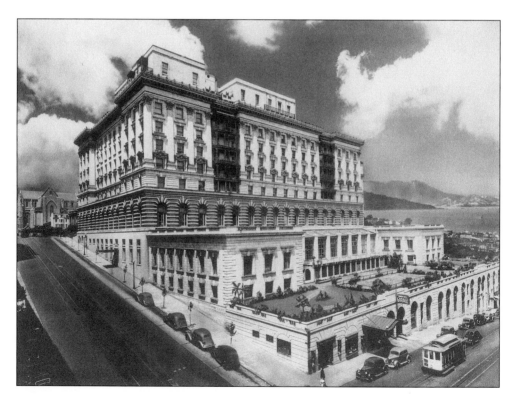

The Fairmont Hotel on California Street in the Nob Hill neighborhood opened in 1907 to mark San Francisco's rebirth after the earthquake and fire of 1906.

CONTENTS

INTRODUCTION

In early October of 1999, two things happened that were vintage Bay Area. *Money Magazine* named San Francisco the best place to live in America because of the city's vibrant culture and booming economy, and the actual Dr. Patch Adams led about 40 naked people down one of San Francisco's busiest streets, Van Ness Avenue, to protest the Y2K peril of Russian nuclear warheads. Obviously, every city has plenty of stories to tell about the weird, the wacky, and the wonderful people and places within its boundaries. With a rich and fascinating past, the San Francisco Bay Area could probably talk forever. This is an area that became famous with the Gold Rush of 1849, was victimized by the worst natural disaster to ever occur in an American metropolis, and has been on the cutting edge of several social phenomena. The flamboyant and cosmopolitan city by the bay and its neighboring municipalities, a world-class tourist destination for its cultural accoutrements and physical beauty, was born to tell stories upon stories.

The first storytellers who lived here were Native Americans. The Oholone Indians, who subsisted quite peacefully with their Miwok neighbors, originally inhabited the locale now known as the San Francisco Bay Area. The destruction of their hunter-gatherer existence began in the 16th century with the invasion of Spanish missionaries and conquerors. Within 200 years, the Oholone people and culture were decimated by disease and forced servitude. Before the entire province of California became U.S. territory in 1848, the flags of England, Spain, Mexico, and the Republic of California flew over the region. It was admitted to the Union in 1850 as the 31st state.

Another group of storytellers were the Forty-Niners, the men and women of the Gold Rush. Within a year of the discovery of gold at Sutter's Mill in 1848 in Coloma, near Sacramento, San Francisco's population swelled from 800 to 25,000 people. That figure more than quadrupled, if you counted the number of transients, those temporary settlers who flocked to the area to seek their fortunes. The city continued to grow after the discovery of the Comstock Lode, a silver strike in western Nevada, in 1859. San Francisco became a teeming sprawl of adventure, violence, gambling, prostitution, get-rich quick schemes, conspicuous consumption, and brazen acquisition of capital—all necessary ingredients of the "Barbary Coast." Additional factors in the city's meteoric rise were the completion of the Central Pacific Railroad in 1869, the introduction of streetcars in the 1870s, and the importation and exploitation of cheap labor, mainly from China.

The children and grandchildren of those fortune-seekers and a passel of immigrants continued telling stories at the turn of the 20th century. By 1900 San Francisco was the nation's ninth largest city with a population of more than 330,000 people. Their lives and property literally tumbled down and exploded on April 18, 1906, with an earthquake and subsequent three-day inferno. Several thousand people died, 250,000 were left homeless, and 3,000 acres of buildings were destroyed. One intriguing story from the devastation involved A.P. Giannini, an Italian immigrant and food broker who retired at 32 to found the Bank of Italy with

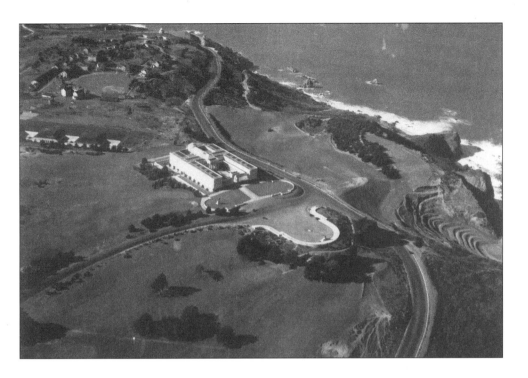

California's Palace of the Legion of Honor was built in 1916 by George Applegarth and reopened in 1995 after a $36-million seismic retrofitting and modernization. It was modeled after the Palais de la Legion d'Honneur in Paris, and was donated to the city by Mr. and Mrs. Adolph Spreckels in remembrance of Californians who died during World War I. This photo was taken in 1928. (Courtesy of the Photo Collection of the Golden Gate National Recreation Area, National Park Service.)

his stepfather. As the flames neared his bank, Giannini removed his assets and records and snuck them home in wagons covered with mounds of fruits and vegetables. His bank—later renamed Bank of America—was the first in San Francisco to reopen.

The San Francisco Bay Area echoes with a plethora of stories on a variety of historically significant events. There was the 1934 strike by Harry Bridges and the International Longshoremen's Association that crippled the docks for three months. After police killed two strikers and wounded 30 more, Bridges called for a general strike. In solidarity, 150,000 workers stayed home, and San Francisco was shut down for three days. The Golden Gate and Bay Bridges, the San Francisco Opera House, and the federal prison on Alcatraz Island were built as construction projects in the 1930s. San Francisco was also home to the Beat Generation, a group of poets and writers like Jack Kerouac and Allen Ginsberg, who feared the A-Bomb and rejected the conformity and rampant materialism of post–World War II America. Not quite 20 years later, another group of young people fed up with the war in Vietnam and the racial and social divisiveness of their parents' generation started a counter-culture explosion known as the Summer of Love. The Bay Area was also the birthplace of the Black Panthers, and of Patty Hearst and the Symbionese Liberation Army (SLA). In 1978 a former city employee, Dan White, murdered San Francisco Mayor George

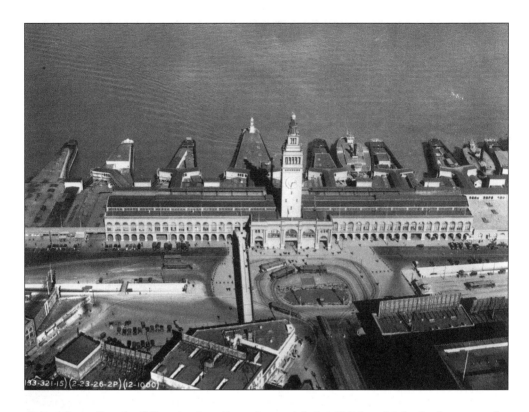

Once the tallest building in San Francisco with its 235-foot-high clock tower, the Ferry Building, built in 1894 and modeled after the Cathedral Tower in Seville, Spain, is now the headquarters of the San Francisco Port Authority and the World Trade Center. Prior to the Golden Gate and Bay Bridges, ferries transported 50 million people a year from around the Bay Area. This photo was taken in 1926. (Courtesy of the Photo Collection of the Golden Gate National Recreation Area, National Park Service.)

Moscone and a city supervisor, Harvey Milk. In the same year, disciples of San Francisco's People's Temple, brainwashed by cult leader Jim Jones, killed a U.S. congressman and his aide, and then committed mass suicide in Guyana. Today, the city has taken an active lead in promoting the rights of gays and lesbians.

These widely divergent social and political phenomena are but a few of the tales that make up the social and political landscape of the San Francisco Bay Area. In addition, there is the heart-stopping beauty of Muir Woods, the rolling hills of the wine country in Napa and Sonoma Counties, and the hundreds of miles of trails and cliffs and coastline of the Golden Gate National Recreation Area. The Bay Area also boasts a variety of ethnic groups, neighborhoods, restaurants, places of worship, nightclubs, sporting events, health clubs, theaters, amusements parks, and musical venues. There are also problems that need to be addressed, including racial strife, homelessness, congested freeways, and strip malls. Stories that present a varied portrait of the area's history—positive and negative—are the ones that truly celebrate the people and places of the San Francisco Bay Area. I have chosen to let nine long-time residents, all of whom were either born in San Francisco or have lived in the

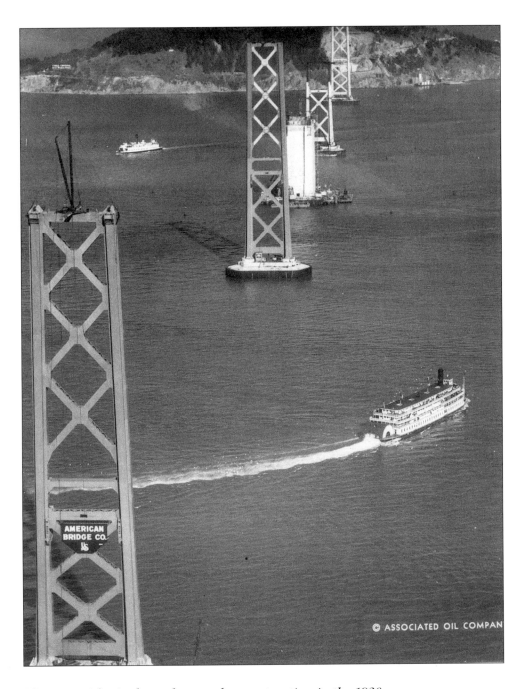

The Bay Bridge is shown here under construction in the 1930s.

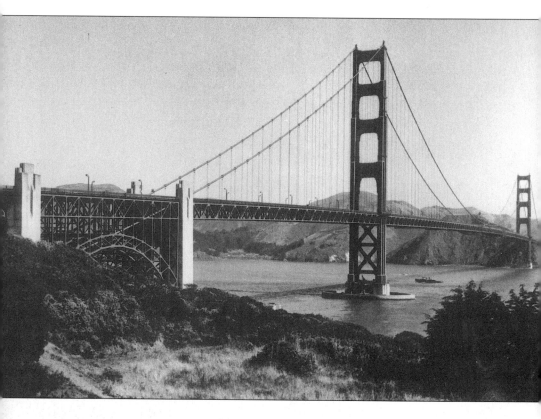

When the Golden Gate Bridge opened in May 1937, more than 200,000 people walked across its span. It was the longest bridge in the world until 1959, when the Verrazano-Narrows opened on Staten Island. Sidewalks were included in the design to accommodate people on foot or bike. (Courtesy of The Anne Thompson Kent California Room, Marin County Library.)

Bay Area for at least 50 years, tell their stories in this volume.

The impetus for this collection of narratives began 3,000 miles away from California, in 1980, when I was 21. I was sitting at the kitchen table in my grandmother's home with her and her older brother, Joe. He had diagrammed on a napkin the town square of their natal town, Brody, which is in Poland. He then spent an hour or two telling stories about the various people and places they hadn't seen since the family migrated to America in 1921. I tape recorded that conversation and pledged to myself to record him further so I could uncover more of my family's history. Joe was the keeper of the family's stories because he was 15 when he, his two sisters and a brother, and his mother arrived at Ellis Island to rejoin my great-grandfather, Morris, who was living in Hartford, Connecticut. Joe was old enough to remember life in the old country. He was the one who knew the thrilling details of how Max, his youngest brother, was rescued from atop a changing table at their home as a Polish mob ransacked the Jewish section of the town. Their sister Lillian snatched up Max just as a soldier thrust a sword through the open window.

But I never sat with Joe again; I wandered through my twenties. I quit college, went to work full-time, and later resumed my undergraduate career. Then, in 1987,

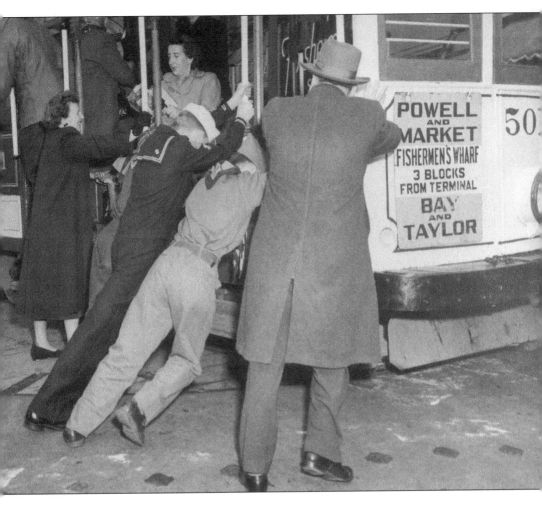

First run in 1873, cable cars traversed the entire city by the 1880s; property values tripled along the routes. Electric streetcars, trolley buses, and gas-powered buses supplanted cable cars, which were declared National Historic Landmarks in 1964. It is still a popular tourist attraction to watch the cable car turn-around at the corner of Powell and Market Streets. (Courtesy of The Anne Thompson Kent California Room, Marin County Library.)

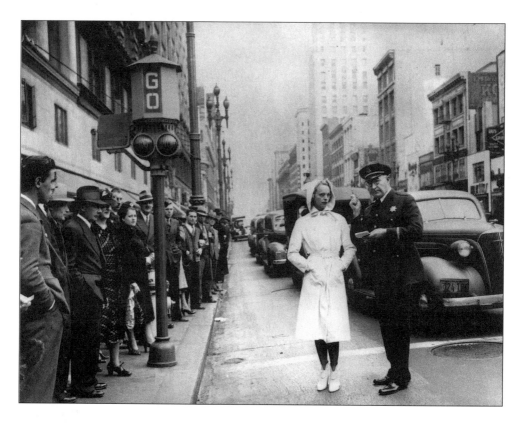

In the early 1940s, a police officer assists a young woman near Powell Street under the gaze of onlookers. (Courtesy of the San Francisco History Center, San Francisco Public Library.)

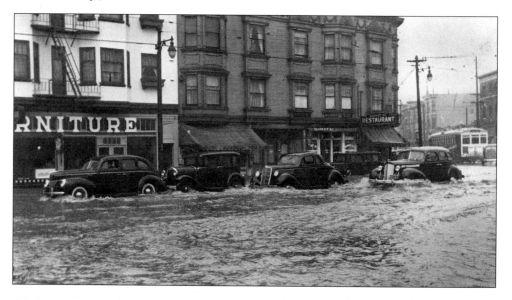

A flood created havoc on the streets of San Francisco in 1941. (Courtesy of the San Francisco History Center, San Francisco Public Library.)

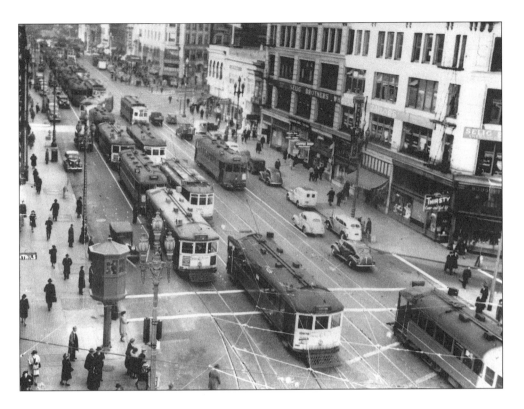

Market Street has been a major artery in San Francisco for many years. Many San Franciscans and people from other locales used streetcars as their mode of transportation. This photo is from the early 1940s. (Courtesy of the San Francisco History Center, San Francisco Public Library.)

he died. An entire repository of information about my ancestors was gone—forever. At the time, though, I didn't connect Joe's death to the loss of such a large part of my background. That realization didn't come until I was a little older and possibly a bit wiser.

My first serious foray into oral history came in 1992. I was looking for a topic for my master's thesis in anthropology, when a friend suggested I speak to her father, William Sinai, a 92-year-old Jewish man who'd been a semiprofessional athlete, dentist, and teller of great stories. Soon after meeting Bill, I decided to write a life history about him. His stories were so fascinating, and we'd become such close friends, that I used our relationship, his moral storytelling, and his athletic and Jewish identities as the basis for my thesis. I have always enjoyed listening to people's stories, but what the experience with Bill really taught me was how healthy and liberating the reminiscing is for those sharing the stories.

I continued listening to stories and helping people reminisce when I volunteered to lead a weekly life history session at Drake Terrace, a retirement facility in San Rafael, California, in the fall of 1993. For four years, I tape recorded those gatherings, which drew from 15 to 25 people every Thursday afternoon for one hour, knowing that someday I might preserve many of the stories in book form.

I was fairly nervous at those initial sessions. As a schoolteacher, I expect people to

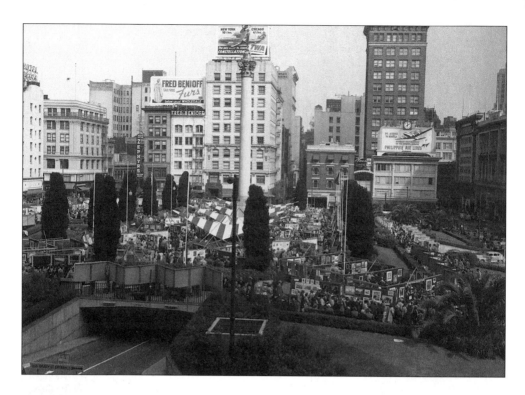

Many people feel that Union Square is San Francisco's most illustrious shopping district. It was built with the city's diversity in mind. The park is filled with chess players, noon-hour lovers, panhandlers, soapbox speakers, and street performers. On nearby streets, there are chic shops, as well as places to buy cheap souvenirs, jewelry, perfume, books, household goods, antiques, Oriental rugs, or art. (Courtesy of The Anne Thompson Kent California Room, Marin County Library.)

raise their hands and volunteer to speak. At the first "Tea and Talk," the name of the weekly encounters, I had the same expectations, but most people avoided eye contact with me as if I'd asked them to explain quantum physics. After five or ten minutes, I just started directing my queries to specific people. "So, Oscar, what did you do for a living?" Or, "Tell me, Wilmine, about where you grew up." Well, it worked. Within weeks "Tea and Talk" was as popular as Tai Chi, and people were thanking me for helping them retrieve so many long-dormant memories. At first I was quite content to ask questions, sit and enjoy the tales, and, if the story warranted, probe more deeply. Within a few months I felt part of the family, but I still preferred to be a facilitator and interlocutor. It took me three years to feel comfortable sharing my own stories in addition to being the group's reminiscence guide. By 1997, though, the life history model had exhausted its welcome. "Tea and Talk" was drawing fewer and fewer people because many of the residents were tired of hearing or sharing any more anecdotes. I took the advice of several residents and modified "Tea and Talk" to include mostly a discussion of current events, with some reminiscing about the past. Today, "Tea and Talk" averages 15 people per week. There are only three residents left who were members of the original group.

The idea for a book was put on the shelf, so to speak. I was working full-time,

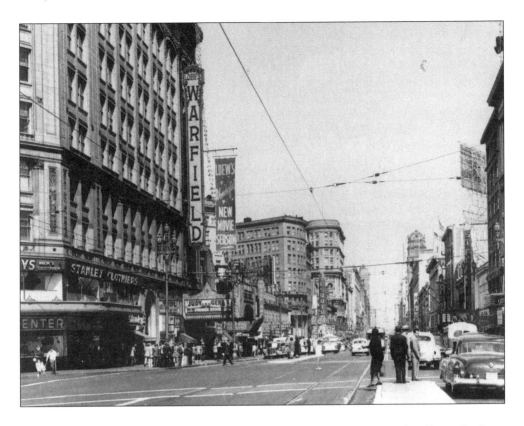

Marcus Loew built the Warfield Theater in 1922 to promote vaudeville and silent-screen productions. Today the theater, which is still located on Market Street, has a full-service nightclub, restaurant, and bar, and presents modern musical acts. (Courtesy of The Anne Thompson Kent California Room, Marin County Library.)

married, and in 1998 my wife and I welcomed a son into the world. In early 1999, however, I decided it was time to resurrect the idea of publishing a volume of oral histories. I wanted to preserve many of the reminiscences I'd collected, not only for the tellers or for myself, but also for as many people as possible. The book would provide a wide audience with valuable nuggets of social history—an opportunity I'd missed by not interviewing my grandmother's brother again. So, after Arcadia agreed to publish this book, I began to find subjects who would fill its pages with their personal narratives. Three of the people in this book live at Drake Terrace: Berenice, Sylvia, and Al; it was easy to interview them because I've known them and their stories for a long time. The other people came to me in a variety of ways. I told my friend Mary Gresham, a nurse and anthropologist, that I wanted to interview a Japanese-American about his or her life, including experiences during internment. One day later, a woman from the Redwoods, a retirement community, phoned to tell me that Mutsu Muneno, an internment survivor who was born an hour outside of San Francisco, would be willing to talk with me. The next day, the National Japanese-American Historical Society in San Francisco referred me to Chizu Iiyama, a long-time advocate for Japanese-Americans and an activist on several social and political issues. I met Michael Killelea and Mr. and Mrs. Contreras through my wife, a paralegal for

the city of San Francisco. Mike is an attorney in her office, and Ciro and Esmerelde Contreras are the parents of one of her colleagues, Jose. I probably met Nora Lee Condra by fate. Two days after one of the women pulled out of the book for personal reasons, I called the Marin City Senior Center, hoping to replace her with another African American. Lurlean, the outreach coordinator at the center, just happened to answer the phone, and after I told her of my dilemma, she recommended I contact her mother. We met, and she agreed to share her engrossing stories.

I was committed from the beginning to having this book reflect the diversity of the Bay Area. Therefore, I chose to interview people from a variety of ethnic and religious backgrounds. Two of the narrators are Jewish, one is African American, one is Irish Catholic, and one is Mexican. Another's family migrated from Mexico, but she's lived in the Bay Area since she was four. Two are Japanese-Americans, and one is from a family with a mixed lineage. The narrators also stretch across both ends of the economic spectrum. Some grew up wealthy, some grew up comfortably middle to upper-middle class, and others knew acute poverty. I met with all but one subject in his or her home or apartment (I talked with Mike in his office) for anywhere from three to six hours. All the interviews were tape recorded and transcribed by someone else, and then I pared down the transcripts into reminiscences that focused on life in the Bay Area. The narratives in this book are from the interviews I conducted. All I have added are transitional sentences, or words and phrases, to help clarify the stories. My goal was to retain the speakers' integrity while making the book accessible and readable. For the sake of narrative flow, I cut and pasted the stories together and grouped everything topically. Another editing decision I made was to remove myself from the final narratives. Even though all the stories I collected were in direct response to my questions, this book is about the narrators. Their memories proceed much better without any interruptions.

There are a few insights I had during the interviews and while reading over the transcripts. First, the power of family is inestimable. Everyone in this book pointed to at least one family member, usually a parent, who was a primary influence in his or her life. They have not forgotten the lessons they learned more than 60, 70, even 80 years ago. Second, I found that everyone has remained active on some level, and this has contributed to his or her overall well-being. Each person is busy with a variety of either physical or mental pursuits that have positively influenced their ability to reminisce. Margaret Clarke, a noted anthropologist who specialized in gerontology, demonstrated that remaining active is one of the vital keys to a healthy life for elders. Third, I discovered that, like the much-older people in this book, I've already begun reinterpreting my past. I yearn for the good old days of hot dogs on toasted buns, the ding-a-ling of the approaching Good Humor ice cream truck in the summertime, or the endless neighborhood games in the dimness of evening, just as the people in this book recalled the simpler times of their youth.

While waxing sentimental for the good old days may be a function of getting older, there's no denying that times have changed. When I was a kid, I lived within a half-hour of nearly 100 relatives—both sets of grandparents, aunts, uncles, great-aunts, great-uncles, and scores of cousins. There was a real sense of connectedness to my past because everyone lived in such close proximity. Today, we are a much more mobile society. Due to a variety of social and economic factors, it is not uncommon for extended families to be geographically separated. What I think we do yearn for, and that we thought we had when we were younger, is a feeling of community. I do believe that sharing stories can help us to reconnect with our pasts and with the

people who are a part of us.

This book is based on a straightforward premise: everyone has a story to tell and preserve. What drew me to this project was the opportunity to help record the interesting experiences of people who, to quote *Chicago Tribune* columnist Bob Greene, "don't make the morning paper or the six o'clock news." Shortly after I began editing the interviews, I read about David Johnson, a columnist for the *Lewiston Morning Tribune* (Idaho), who has, since 1984, contacted one person each week from the telephone directory and asked him or her if he could record that person's story in his front page column. He published a collection of his stories, *The Best of Everyone Has a Story to Tell*, and it provides a wonderful window into the lives of everyday people. Johnson showed (and I hope I have, too) that the stories have tremendous value and power. My friend Charley Kempthorne summed it up best: "We tend to focus on those stories that we take to be clever, amusing, or insightful. That's fine, but the great bulk of the stories we have inside us aren't like that; they're just bits and pieces of experience. When people take the time to tell their own stories and to listen to others', rancor and bitterness tend to fall away. Not completely, of course, but little by little." If these snapshots of memory from the San Francisco Bay Area accomplish that to any degree, I'll be very happy.

Even though my name is on the front cover, this book would not have happened if it weren't for several people. I'd like to thank the nine men and women whose recollections you'll soon read. They welcomed me into their memories and shared some mighty fine stories. I appreciate the editorial assistance of Allison Carpenter, from Arcadia Publishing, who helped me throughout this project. I cherish the following people for their generous support: Rose and David Buechler, Arlene and Marshall Bush, DeeDee and Paul Epp, Amy and Scott Friedman, Chandra and Len Gordon, Julie and Seth Jacobs, Val Litwack of Caledonia Camera in Sausalito, Debbie and Gideon Mann, Robin and Andy Meisel and their family foundation, Helaine and Rudy Melnitzer, Varda and Irving Rabin, Naomi and Marty Rayman, Milton and Martha Rosenberg, Dorothy and Hal Thau, Kaki and Tib Tusler, Barbara Perlman-Whyman and Andy Whyman, and Bobbie and Rich Zane. I'd like to thank the staffs of the Berkeley Historical Society Museum, the California Room at the Marin County Library, the Presidio Archives, the National Japanese-American Historical Society, and the San Francisco History Center at the San Francisco Public Library for their guidance and photographs. A few people deserve special recognition for their invaluable contributions: my aunt and uncle, Sandy and Arnold Bernstein; Susan Edwards and her entire staff, who have been constant pillars of support and friendship since I started volunteering at Drake Terrace; Amy Rowell, a true friend for nearly 20 years; and my in-laws, Martin and Maria Wefald, who have always been more than willing to help me in so many ways. I am very grateful to my newest friend, Audrey Kolb, for the many hours she spent transcribing the interviews. I'd like to thank my parents, Beverly Bernstein-Prass and Marvin Friedman, and their spouses, Joyce Friedman and Fred Prass, for their love.

This book is dedicated to the two people who bring the most joy and blessing to my life: my best friend and wife, Verna Wefald, and my best buddy and our son, Miguel. Just watching them, together or alone, is a treat that causes me to smile inside and out.

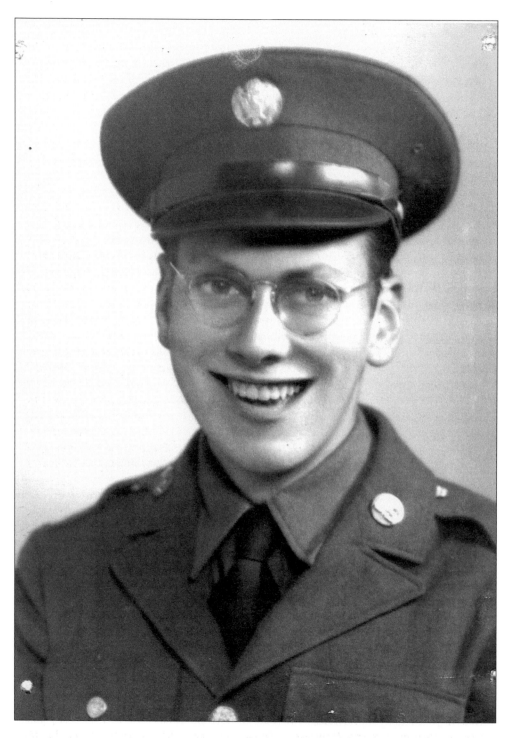

Al, who was a member of the ROTC, enlisted in the army before the United States entered World War II. Attached to the medical corps, he was at Pearl Harbor shortly after the Japanese bombed it. He later served in the Philippines. (Courtesy of Albert Sonne.)

CHAPTER ONE
ALBERT SONNE

When I first met Al and his wife Dorothy, I thought he was an enigma. On one hand, he seemed out of it, not too aware of the conversations that make up "Tea and Talk." He kind of stumbled along, sometimes with a cane, a Nike cap usually atop his head, wearing radio headphones as if they were permanently attached. Constantly tuned to abrasive right-wing talk shows, it was easy to assume that Al was in his own world. On the other hand, I soon learned that he has a steel-trap memory. On several occasions we've begun "Tea and Talk" with five to ten trivia questions on the people, places, and events from the 1930s, 1940s, and 1950s. Al is invariably the first one to know the name of an obscure comedian from radio or the early days of television, or an actress who starred in more than one Busby Berkeley musical, or which radio jingle went with what product and who the sponsor was. One time we were discussing cosmetic surgery, and I was trying to recall the name of a comedienne who had a face-lift and joked about it. I kept saying, "The loud one. The loud one." Al was hunched over and not even paying attention, when he suddenly blurted out, "Phyllis Diller!" It's clear that Al was never foggy; rather, he's always been able to follow a radio show, daydream, and pay attention to a room full of people conversing on several topics. And he makes it look easy. I just didn't notice that right away.

I also understand that Al has always been a salesman. He knew how to sweet-talk the customer and close the deal, and he knew the value of treating people with respect. The push and pull of both these aspects of sales make up the very human contradiction that is Al Sonne. He was a person who enjoyed being a good 'borax' man, manipulating a customer for extra profit and commission. But he is also someone who reads the Bible daily and decries the fact that this country has few political leaders with any moral courage. I've watched and listened to Al as he told an 89-year-old woman how lovely she looked. His mouth curled into a smile, and his eyes started to twinkle as he paid the compliment, and I knew he was sincere. I saw Al strike up a conversation with someone he hadn't seen in five decades, a Bay Area rancher whose business and home he helped to furnish. Al related to him as if their most recent transaction had been yesterday. They swapped stories and filled in the gaps left by the passing of 50 years, and Al made the rancher feel that he was still important to him.

Al sold furniture, appliances, and other household items. For 40 years, he plied his trade throughout San Francisco. He earned good money, was trusted by his clients, and he knew how to move whatever he was selling. The hard-sell techniques, like being a 'borax' man, were honed after Al left his father's employ in the late 1940s. Prior to that, he learned much of his intensity at the feet of his father, George, a successful San Francisco entrepreneur who ran his own company

for nearly 50 years. Al joined his dad almost immediately after the end of World War II, where he spent much of his time in the Philippines. But Al was more than a fast-talking salesman who would try to dazzle and pressure you with his pitch; he was and is a people person. He loved connecting with people and establishing relationships with his customers. Al also wanted to better himself for personal and professional reasons. He grew tired of the appliances business, so he completed coursework at the Bob Bale Institute of Personal Development, the Youngstown Steel Kitchens' Training, and the Chicago Institute of Interior Decorating. He wanted enough knowledge of various trades so that he could provide the kind of service that made the customer feel pampered.

Underneath Al's salesman's persona is a guy who has always liked to have fun. He was a devoted family man and clearly cherishes his wife; but, when I think of his celebration of life, two images stand out. One is from the time he shared a story about attending high school proms. He drew in a couple of deep breaths before he spoke, closed his eyes, and then started to reminisce as if he was actually back at the school auditorium. His whole face glowed at the memories. The other time came as he recalled the almost ineffable joy of getting a free candy bar as a kid. He said, "That made for a bright day. It didn't take that much to get me excited, and it showed the simplicity of life."

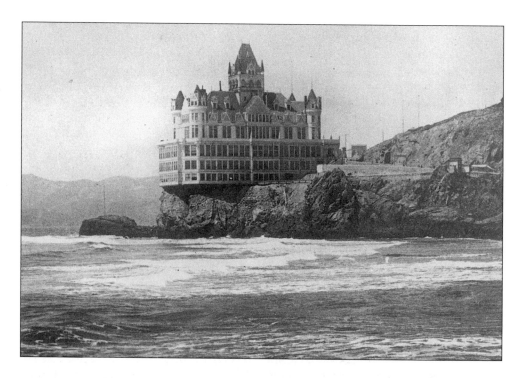

First built in 1863, the Cliff House, pictured here, was rebuilt in 1896 by Adolf Sutro and was located next to Sutro Baths. The third version of the Cliff House survived the 1906 quake and fire. (Courtesy of the Photo Collection of the Golden Gate National Recreation Area, National Park Service.)

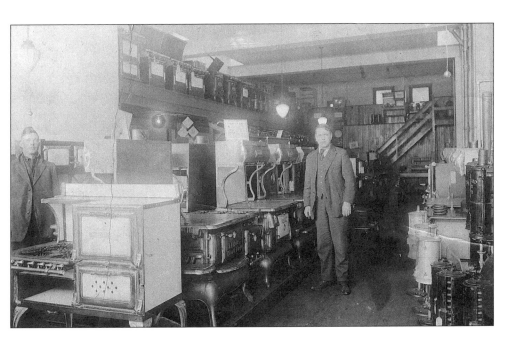

Al's father, George P. Sonne, stands amid the gas stoves and ranges in his newly opened store on Valencia Street in San Francisco in 1907. (Courtesy of Albert Sonne.)

I was born with influenza on January 3, the day after the armistice was signed in 1919. They had me listed on my birth certificate as dead, but they had to redo the whole thing. At that time, I don't think they even knew what resuscitate meant, and there was a whole load of people dying in the hospitals because of the influenza epidemic.

My grandfather was a Bostonian sea captain who went to Liverpool, England, to get his education. He was in the Spanish-American War and navigated all throughout the conflict. His family wouldn't talk to him because he married a commoner. My grandmother's great-aunt was George M. Cohan's mother. He wrote "Give My Regards to Broadway," "Yankee Doodle Dandy," and all that.

My mother was born and raised in San Francisco. As a young girl, she worked for a company in San Francisco. My dad's brother was married to someone whose family owned the company, and they introduced my parents to each other. My dad got started in gas appliances. There was no refrigeration in those days; he just repaired stoves and water heaters, and installed them. He made his first money off airtight sheet-metal stoves. In 1907 his company, George P. Sonne, located on 524 Valencia Street in San Francisco, put in the first gas stove and the first gas heater after the fire and earthquake of 1906.

Much of the city was all sand dunes, and my dad used to take a team of horses and go with the sled to deliver those old coal and wood ranges. A service call in those days was $2. During World War II, we had the only full-service shop in San Francisco and the East Bay, and my dad had seven trucks by that time. The motto on the side of each of the trucks was "We have a modern kitchen for you."

We were upper middle class, and my parents led a modern life. My mother was the

disciplinarian, but there weren't as many punishments as there were expressions. They raised three kids, bought all kinds of real estate, a used car lot on Valencia Street, and the Crown Hotel. My dad also built a pair of flats on 18th Street, where we lived when I was first born, and purchased a big apartment house on 2345 Washington Street. Then we moved to 9th Avenue and Noriega Street in the Sunset District. My brother and I used to cut wood for the furnace with the crates that came with the stove deliveries for my dad's store. We also put coal in the furnace. As a little kid, I used to take crayons and put them against the red, hot furnace and watch them melt down. Life was slower, yet it was fun.

At our house in the Sunset, we'd have parties for the Shriner's East-West football game, one of the big college all-star games at Stanford University that benefits the Shriner's Hospital. There used to be limousines out front; Governor Earl Warren and Mayor Elmer Robinson and senators would be there. We had a basement—we called it Sonne's Inferno—just for entertaining. There was a jukebox, and slot and pinball machines. The room was stucco, painted red with the highlights in silver. My brother, who was seven years older, did most of the work when he was about fifteen. He even made a regular back-bar with the stairs and a mirror. It was really a knockout, and all the people liked to come back there. We used to have New Year's parties with about 50 people. Later on, my mother and father moved us to Marin County, and my father built a 12-room home in Belvedere. We used to have parties there with 50 to 100 people.

I lived much of my life on 9th Avenue at Noriega Street. There was a mom-and-pop store where we used to get licorice, a big, long wick, for 1¢. We used to get the housy-housies, a little square candy, and when you bit it, if it was white you lost, but if it was pink, you got a free candy bar. There was also a deli near us run by Frank Brevett and Archie Bracco. Archie Bracco was about 18 when they went into the business, and Frank was 12 or 13 years older. We used to get an orange cheese, Tillamook Cheddar, and they had this machine where they'd measure it and slice it right then and there. This was when you didn't have refrigeration like today. The iceman would bring over 100 pounds of ice and put it in this cabinet in Frank and Archie's store, and it would refrigerate the whole thing. Anyway, the two of them were very successful. Then they bought the property across the street and built a beautiful market on the corner, and we went on doing business with them all the way through. Archie's went on for years and years. After we moved to Marin, his son was behind the counter, and later, they sold the building, and an athletic equipment business came in there. And that was the end of Archie's, but they had an enormous amount of money because they'd been there from when Archie was a teenager. Right across from my house was the butcher, Abe Gutman, and his two sons. They put in refrigeration, a big walk-in refrigerator in the rear and a display in the front. We'd have Archie and Frank give us hot dogs, and then Abe would give us hot dogs, and we'd have a barbecue on the empty lot that was right next to our house. Then Abe's two boys would come to us and get their hot dogs to eat. Another thing we did in that lot was to set up gardens that we cultivated and took care of.

Another place where we did a lot of our shopping, once every two or three weeks, was the Crystal Palace Market on 8th and Market Streets—near Benatar's Drugstore and Weinstein's Clothing and Department Store. It was mammoth and impressive to a little child; it was like a beautiful fair going on. There were all these vendors, and you could clothe and feed your whole family; everything was sold there. Each vendor was independent and only sold one product. I'll never forget the molasses candy.

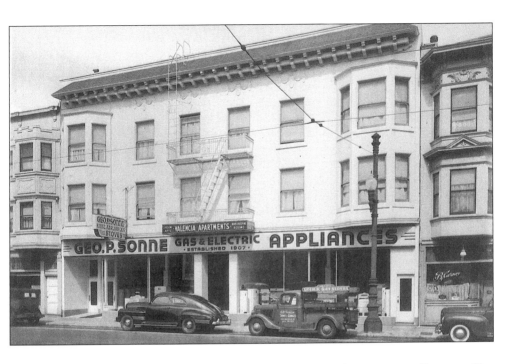

George's store, which had branched out into electric appliances as well, was still a San Francisco business fixture in the 1940s. (Courtesy of Albert Sonne.)

There was a machine with the molasses candy going around, stretching, and that was all it did. I can remember how they displayed the celery like it was yesterday. It was all like flowers instead of just being thrown together. There were also dipped, candied apples that were sold at the market. Many of the food vendors had food shows at the San Francisco Civic Auditorium, which was renamed in memory of rock and roll promoter Bill Graham a few years ago. The upstairs of the auditorium, this was before there was a downstairs, was loaded with food. The biggest thing was when they introduced margarine. It was white, but they gave you a little packet filled with the coloring, which you added to make it yellow. Back at the market, they were always demonstrating something, a knife or some other gadget. A man would stand up there, barking at you about the product. Besides family shopping, my mother would go there to buy curtains and utensils for the apartment building she and my father owned at 2345 Washington Street.

Unfortunately I went to eleven schools because it was during the time of the earthquake scares. They had to rebuild whole schools to make them safe with fire escapes and all that stuff. So when I was at Columbus School out on 12th Avenue, they shoved me over to Laguna Honda. Then Laguna Honda had to be repaired, so they shoved me out to Jefferson. From Jefferson I went to another one. And when I was in high school, they shoved me from Polytechnic High to Samuel Gomper's Trade School for Boys.

My first two schools were private ones. I went to kindergarten at the Charing Cross School. There were about 50 kids in the school. For first through third grades, I went to Potter's School. I was there with Zellerbach, Vic Valencia of Valencia Street, Louie Sutter of Sutter Street, and Jeff O'Farrell of O'Farrell Street. Sutter lived up on

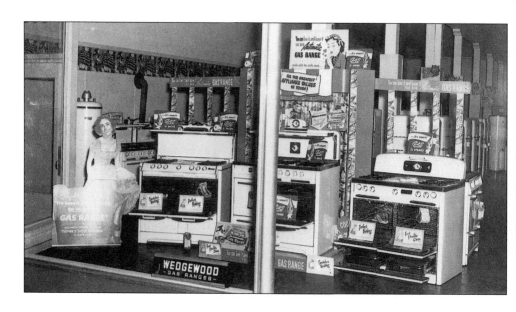

A cardboard cut-out of Elizabeth Taylor advertised Wedgewood gas ranges in the 1950s window of Sonne Appliances. (Courtesy of Albert Sonne.)

Dolores Heights. San Francisco was enormously big, yet it was a little cluster. I used to have a chauffeur, a colored guy, who was included in the tuition of Potter's; his name was Hill, and he was a character. He'd pick me up after, and sometimes during, school and deliver me home about five o'clock. We'd go to Golden Gate Park and raise hell, play games, and sometimes he would take me to the museum and things like that. After third grade, I left Potter's School and went to a public school because we had good ones out in the Avenues, the neighborhood where we lived.

I'm not going to tell you I was a high-end student; I wasn't. The only time I really got A's was in the history of music. As far as interest in school, I didn't have it. I guess I was a dreamer, and I wanted to go into the fantasy. And when it came down to reality, reality got pretty mean at times in school because I had to apply myself. And there were different regulations in school. When we got punished, we got a ruler in our hands. I got in trouble for something we used to call fibbing, not lying. One of my teachers, Mrs. Boglesine, would give me soap to bite on. Then you had to get it out of your mouth, which is something you always remembered. Back then you could actually recall when you were bad or something. Today, the kids got it too easy.

I had it pretty easy, too. Instead of applying myself in school, I spent lots of time going out with friends. I did this a lot in my teens and twenties. I was never into smoking or cheating or drinking, but I liked to have a good time. One thing I was serious about happened when I was around ten or eleven. It was Prohibition, and at the Presbyterian Church we attended, they were trying to get the kids swayed against liquor. They taught us to sing "Dirty Old Red Wine:" "We turn down our glasses. We turn down our glasses. We turn down our glasses for dirty old red wine." They asked us to take a pledge that we'd never touch alcohol, and it was something that penetrated inside, that was impressive and stuck with me. I went through the service and never took a drink, and I haven't had one since the pledge, which I took in 1930 or so. It'll stick with me until I leave this earth. It wasn't like I couldn't be around

alcohol. My family was social drinkers, and my dad used to have the bootlegger deliver a demijohn in the garage at night. A demijohn is a glass gallon jug with wicker on the outside of it. It looked like a root beer keg but it was filled with alcohol. It was a half gallon or gallon bottle that had weaving, not rattan, on the outside. They were used to preserve and disguise the alcohol, which had to be kept at a certain temperature.

Anyway, I remember so many of the places I used to go to before and after World War II. When I was in Everett Junior High, we went to Daniels Creamery on Sanchez and Sixteenth Streets. Their entire family served us, and I saw them grow up. We'd go in there and get a hamburger with pickles and relish—everything. And then we'd get a scoop of sherbet and a milkshake, a big one, for 30¢. The Daniels Family also used to have a restaurant in the Sunset with old English ice cream and other frozen desserts. It was beautiful. The interior was red and black with red leather all the way around. We used to go there in high school, and Polytechnic, my school, was on one side, and Lowell was on the other. We would all get together after a ball game, and with the two schools on opposite sides it was like a competition. But it was a place where they allowed the kids to go in because it was a creamery. It was where a girl met a boy and things like that.

When I was older, I went to the Variety Club in San Francisco. Performers would come out of different entertaining spots at one or two in the morning and go to a jam session at the Variety Club. The jam session would last until four a.m., and then we'd go to breakfast at Coffee Dan's. At Coffee Dan's, they gave you a hammer, and everyone would start singing and banging the hammers on the tabletops. The harder you hit the tabletop, the better it was. We hammered to the rhythm of the music until daylight. There was also a great nightlife in the hotels. We went to the Fairmont, which had the Venetian and Polynesian Rooms. There was a swimming pool in the Polynesian Room and an orchestra out on a little island. You could hear the water rushing back and forth; it was romantic.

Other times we went to Ocean Beach out by the Cliff House. There was Topsy's Roost, and when you came there, you'd have to go down a slide to enter. Men and women all went down the slide into the restaurant. They served chicken in a straw, which was fried chicken with French fried potatoes. And the whole thing was about 80¢ or $1. There was the Edgewater Inn, with a beautiful dining room downstairs and a nightclub and whorehouse going full blast upstairs. It was wild but subdued. There was also Tate's at the Beach and Shorty Robert's. Over in North Beach, there was a full nightclub, the Bell Champer Inn, which sometimes had the likes of Ann Miller dancing there. There was a lot of variety in that neighborhood with places like Club Lido, the Sinaloa, and Ray Goldman's Gay Nineties. Women in those days could still walk around at two or three in the morning.

A lot of the nightclubs and taverns had to hide themselves on account of Prohibition. On Valencia Street they had all these cocktail clubs, and you went upstairs, and the blind pig would let you in. "Blind pig" was a slang name for the whole era of covering up nightclubs. For example, two guys, Hatch and Ore, had this store with a big root beer barrel on the counter. They'd pour the root beer, and it had a gorgeous foam head, and put in a scoop of ice cream. Or, they'd go in back and get you a drink or a bottle—whatever anyone wanted. It was a soda fountain in the front and an illegal package store in the back. Then there was the Mission Inn. Their men's room was very popular because there was a whole lineup of slot machines. The policemen knew everything that was going on.

I started having fun at a very young age. I went to the movies a lot. You'd go to see two movies at the Fox Theater, and then you'd see a full floor show. There'd be a girl singing and dancing, or maybe, some people would be there from one of the dance studios. Then there'd be a violinist or a couple of kids or three would be playing together. You couldn't purchase candy or anything in the theaters, but they'd give you a bowl of something. And you got to keep the bowl. Then you'd come back the next week, and they had dish night, or they'd give you a cup or a plate or a saucer. So we'd get a set of dishes out of going to the movies. They'd give away pots and pans the same way. Sometimes you had the chance to win one, two, or up to ten silver dollars. It was a way to attract people to the movies. Another way was they'd have bag night, and you'd walk to all the merchants near the theater, and they would give away groceries, light bulbs, flowers, and all different things. Many times you would walk home from the movies with a big heavy bag of groceries. But that's what made the neighborhood show so profitable in those days. There was a movie theater on Irving Street, a small one we used to call The Fleahouse. We'd go every week, for example, to see one of the serials like the Green Archer. There wasn't any color in those days, and we never had sound, so we would have to read the movie. If we were at Searsville Lake or down on the Peninsula [south of San Francisco], we made our parents leave and come all the way home so we could see the Green Archer. Those were fun days.

We also had fun at one of the neighbor's homes. He lived down the street and had a garage, a good high garage. My brother George and I would ride down from the roof on a board with skater's wheels and land right in the sand. Also, a bunch of us, when we were around 12 or 13, used to get old baseballs, soak them in gasoline, and wrap them with tape. Then we'd go up to the sand dunes and throw them like bombs. And the bomb would blow out of the baseball and explode against the sand dune. We never hurt anybody; it just had enough kick to make the sand blow up.

Another thing I remember as a child is how we used to climb on and ride the bumpers of the streetcars. Each streetcar in those days always had a motorman and a conductor. I could take the Number 6 car, with two or three friends, all the way to Noriega Street before the streetcar officials would catch up with us. The car started on Market Street and eventually went up Ninth Avenue, which was near where we lived. Another type of transportation you don't see anymore is the jitneys. Jitneys we'd get downtown or anywhere, and you could go all the way out to Daly City for 25¢. That was unheard of in those days. We had railroad streetcars that went all the way down on the Peninsula to Burlingame. Transportation was different in those days. It was cheap, but it was much, much more put together than it is today. We used to take the old cable cars before they were rebuilt. They were rebuilt about 1953, and they put in a new cable system. Ever since then, they've been seen as a novelty.

One time in high school, we took off the two rear tires of this guy's car and left it jacked up there. We even bought a bunch of wood and tacked it together so we could have the other side the same level as the side on the jack. That's the worst thing we ever did. At Polytechnic there was no parking lot and no meters; you'd just get a parking space and park all day. After a certain amount of time, we'd cut school and sit in our cars, get some girls, and go driving.

I always enjoyed being with girls. My first case of puppy love was Viola Leahy, seven years old. She was a girl who I used to split my sucker stick with. The lollipop was on one end like a barbell, and I used to break it in half and we'd each have one. We'd known each other from when we were three years old. I remember other

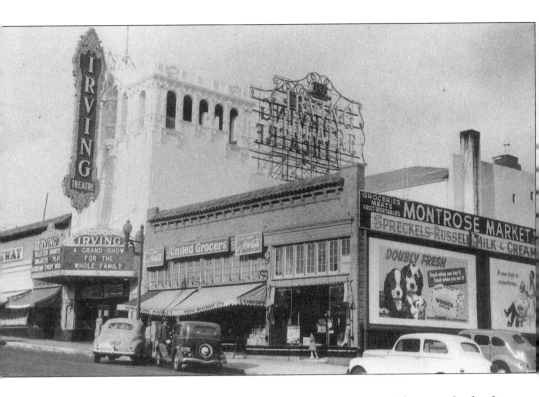

Al and his friends and family frequented the first of two Irving Theaters, both of which were located on Irving Street near 10th Avenue and have since been torn down. (Courtesy of the San Francisco History Center, San Francisco Public Library.)

girlfriends I had before I turned 12: Jeanne, Agnes, Marie, Lorraine, and Ady. I can recall to the day when Agnes had a dress on once, and she pulled her pants down. She had on bloomers and then she brought them up. They were just white, blunt white pants for girls in those days. We never saw anything; she was showing how devilish she could be.

I went to my first big dance when I was at Everett Junior High School. We had a graduation prom when we left the 8th grade. The school was built during the Depression, and it had tile and everything in it. They went all out when they were building it because the money was so cheap—meaning you could do a lot with fewer dollars. There was a big auditorium that we decorated for the dance, and there was a big crystal ball hanging in the center. We were all dressed up—long dresses for the girls and suits for the boys—and we went to dinner first. There were these dance cards that went on the girl's hand, and the boys had to enter the different dance times that we wanted to dance with them. I went with Janet, who had just come into the school. She was 13 and a couple of years younger, but something clicked when we first met. At the dance, I remember the ball twirling around, and it was kind of romantic.

My first prom was a blind date. She was going to school at the Lone Mountain Catholic convent [today it's part of the University of San Francisco]. A friend of mine, Pat Pollock, arranged the date, and I went up to the convent school to get her with another friend's car. She was a Greek girl, Cia Madakas. I gave her a corsage. Oh, she

was all decked out and, God, she was a knockout. She was a gorgeous girl, and you'd look into her eyes and melt. We got back to the kitchen of the convent at one-thirty or two in the morning, just as they were getting ready to prepare breakfast, so we asked for cereal. Well, the Mother Superior said to me, "See that door? You, young man, go out that door and that's it."

Janet and I went together during high school and when I went in the service after I graduated. In high school I was in the ROTC—rotten old tin cans, we called it—and I enlisted in 1940. I went to other proms, one at the Drake Hotel in San Francisco and another at the Claremont in Oakland. I went to a few proms without Janet because those were the times we were on the outs. But I gave her an engagement ring when I was eighteen. It was a beautiful ring, but her mother, who never liked me, took the ring while I was in the army and had it remounted. I didn't know this at the time because Janet and I drifted apart during the war.

Overseas I always had a bunch of gals. I proposed and was engaged to many girls, and I just gave rings away. But when I came back, I looked up Janet. I walked to her old address, down the hallway, and there she was. Things clicked again. I talked to her mother, and we worked things out. She liked me, and I found out she'd always liked me. I even bought her mom a stereo for Christmas in 1946. Janet was married to a sea captain who was a very brilliant person. I helped arrange the divorce while he was out in the water on this big ship. So, Janet and I started dating again, and all of a sudden we got engaged. I gave her another ring—bigger and better—and then we moved into an apartment I'd found on Pierce Street. Her mother had an engagement party for us at the Claremont Hotel, and we were going to get married at the end of 1947. At the time, Janet was the youngest buyer ever in California for the White House Department Store. She had to fly down to Los Angeles on business. The pilot and the co-pilot got into a fight, so the plane hit some mountain range down south, near Los Angeles. They couldn't reach her mother, so they called me. I had to identify her, but the only thing I could go by was one of those partial plates in her mouth. The ring was completely gone.

I met my wife Dorothy at the home of a Masonic brother, Chet. Chet asked me to take her home. He had two daughters, and Dorothy was their teacher. I knew Dorothy was the one, because she was comfortable with me. I didn't feel any pressure from her, which is something I don't like. She lived at a Catholic residence hall in the city, but she was originally from South Dakota. She returned to South Dakota after some time, but when she came back, we got married at an Episcopal Church near my family's home in Belvedere. When we were first married, we stayed downstairs in Belvedere, then we bought our home in Strawberry, a small neighborhood near Tiburon and Mill Valley. We lived there for 46 years. Dorothy and I like home parties; picnics; dinner dances, especially with the Masonic Order; and organization. We were married in 1949.

My first job was actually with my dad on Valencia Street after the war. My dad and I worked together like close family, and we never crossed fires or anything. The only time he gave me hell was when I smoked and dropped the cigarette butts on the floor of the store. By the end of the day, the floor would be white because I was very nervous back then—after the war. From there I went to Bradbury's Commercial College, and after they went out of business, I went to Munson's School of Business. The odd thing about my first job was that my dad's business was across the street from Ramm Furniture, the store I later managed. Later on I worked for L.R. Jackson on Clement Street; this was a furniture and household appliances kind of business.

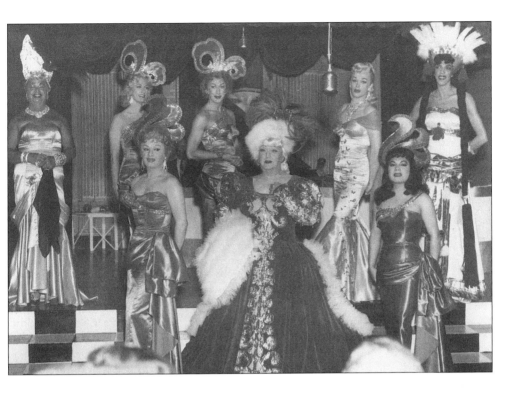

Since the 1920s, Finocchio's has been the site of fairly tame (for San Francisco) drag revues with female impersonators, wild costumes, and raunchy humor. (Courtesy of the San Francisco History Center, San Francisco Public Library.)

Years earlier, my dad had had a contract to deliver and install stoves for them when the business was called G.B. Jackson, which was named for the father and was on 10th Avenue and Clement Street.

I didn't like to be confined to one thing, so I put all my time into active jobs; I went from sales to management, and I remember working until two-thirty or three in the morning just to see that a carpeting job was done right. I furnished all the rest homes in the Richmond District. I guess I learned that from my father; I never knew him any other way; he was always into business. Another thing that I learned came from Adrian Gruin, owner of Great Western Furniture, who taught me the "borax" end of the business. Like, if we sold a chest with drawers for $39, we'd get $4 apiece for the handles. After we got that much money, then we billed and billed them. Or we'd advertise a five-piece dining room set for a real low price. Then when the person would come in, we'd tell him it was the table and the four legs. Once someone comes in, there's a good chance you'll make a sale. A good borax man or woman would start one way and then just keep building, and the customers would often be cheated in a way.

One thing that I always liked about Mr. Steven Ramm was that he stood behind the merchandise. If a customer was on the books and paying off a sofa and bedroom and all that, and wanted a change, we'd take back the old items and work out a new contract at the same money per month, or maybe just a little bit more. Then we'd give the customer something brand new. That was nice.

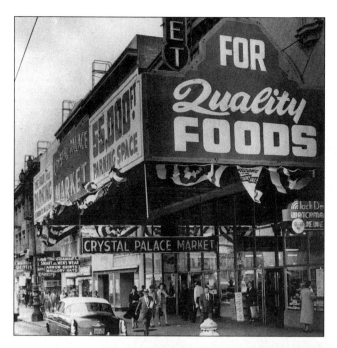

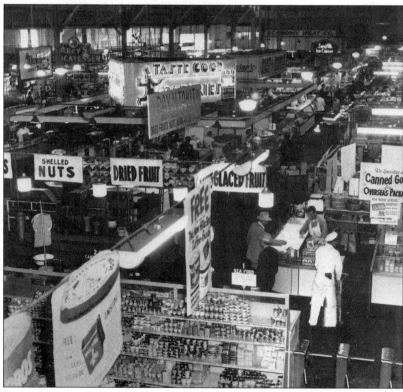

Crystal Palace Market, located at 8th and Market Streets in San Francisco, served shoppers for more than 30 years. Vendors hawking everything from fresh fruits and vegetables to meat, chicken, and fish, and from housewares, furniture, and clothing

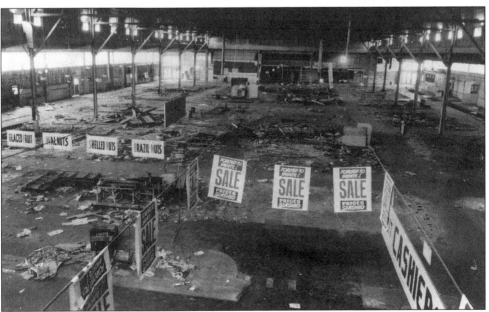

to pharmaceuticals, sweets, and bulk food items drew people of all ages. The indoor "flea market" closed its doors forever on August 1, 1959. (Courtesy of the San Francisco History Center, San Francisco Public Library.)

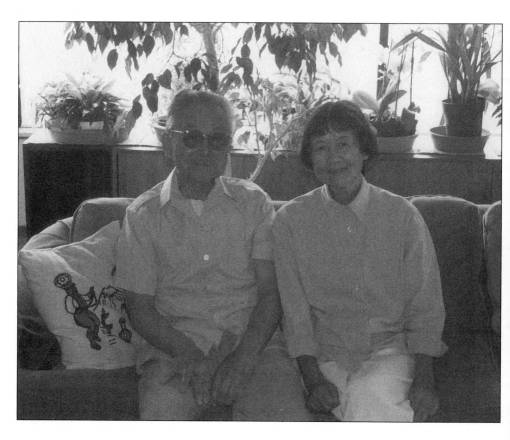

Ernie and Chizu Iiyama sit in their living room in September 1999. (Photo taken by Steven Friedman.)

CHAPTER TWO
CHIZU IIYAMA

I think it's true that young children have some kind of radar that senses warm and inviting people, because the first time my son went with me to Chizu and Ernie Iiyama's house, he bounded in as if he knew the place. This toddler, who is typically subdued and shy in new social situations, ran with Mr. Iiyama to the large dining room window, climbed onto a chair, and gaggled with joy over the view of El Cerrito Valley. With Mr. Iiyama holding him while I talked with Mrs. Iiyama, he pointed out the subway trains, the trees, and some other things that are only intelligible to people under the age of two.

Mrs. Iiyama, who was born in 1921, and her husband radiate a positive affirmation of life. In what she calls the defining experience of her life and the lives of so many people of Japanese ancestry, Mrs. Iiyama and her husband, American citizens, were interned during World War II because they were of Japanese descent. Despite the suffering and humiliation, which could've easily caused anyone to become bitter and angry, they have a presence about them that makes people feel welcome. Neither of them has ever retreated from the day-to-day grind of living and working and experiencing what life has to offer. They met at an internment camp where Mr. Iiyama had been involved in progressive politics. And, they continued their passion and commitment to social justice causes after they left the camps and after the war. They lived in New York City until 1948 and then moved to Chicago, where they worked, and Mrs. Iiyama attended the University of Chicago for her master's degree in education with an emphasis in child development.

They returned to the Bay Area in 1955. She volunteered for many local agencies, was the chairperson of the Human Relations Commission of El Cerrito, and was a member of the Human Relations Council of Richmond, which is the city next to El Cerrito. She spent 17 years as the head of the early childhood education department of Contra Costa College. She also worked in the first Headstart program in Berkeley, and in special education classes. Her husband was a machinist. They are proud of their work with the American Labor Party, the Japanese Committee for American Democracy, the Chicago Resettler's Committee, which was formed to resettle the Japanese as they returned from the internment camps, and other left-wing groups at a time when associating with these organizations often meant social and professional ostracism. They've raised three children. The Iiyama's idealism has contributed to one of them, a daughter, who carried on the radical torch in the 1964 Free Speech Movement and the anti-Vietnam War Movement at the University of California at Berkeley. She continues this trend as a union organizer in the textile industry and as a current member of the Socialist Workers' Party. All their children pursued the path of higher education, following the examples passed down to them by Mr. and Mrs. Iiyama and both sets

of grandparents.

It doesn't take much to realize that Mr. and Mrs. Iiyama's humanity was honed during their time at two internment camps. She had the opportunity to leave the temporary camp they were sent to in 1942 to attend Smith College in Massachusetts, but her mother refused permission (Mrs. Iiyama was only 20 at the time) because she didn't want to break up the family any further after her husband had been taken away. After the war, Chizu and Ernie learned first-hand about the destruction that hate brings from listening to Mr. Iiyama's mother who was in Hiroshima when the United States dropped the atomic bomb. The Iiyamas decided to help the survivors of this tragedy after hearing his mother speak of those who perished instantly and those who lingered in pain before dying. Today, she and her husband remain active elders, who are involved in a variety of social and political issues in their community. They are avid travelers who are very interested in history and archeology. They have participated in several archeological digs, most recently at a Navajo school in the fall of 1999. Both love the arts and gardening, and Mrs. Iiyama still finds the time to help Japanese Americans throughout the Bay Area record their oral histories.

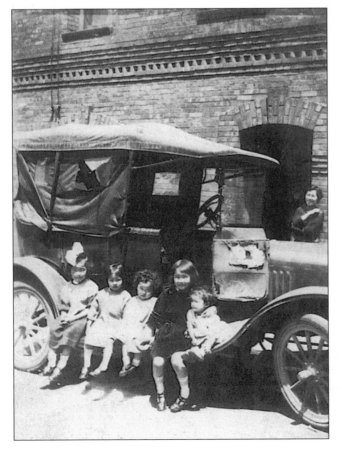

Chizu, in the black dress, poses with her siblings on the running board of the family's car in Chinatown in the 1920s. (Courtesy of Chizu Iiyama.)

My father came to the Bay Area from Japan in 1906. He lived in Oakland at the time of the earthquake and saw San Francisco in flames. My mother came as a picture bride in 1914. There were a lot of restrictions on Japanese immigration during that period before it actually stopped in 1924. Between 1910 and 1924, though, the United States government allowed the wives of men who were already here to come in. So single Japanese men wrote to their parents and relatives in Japan asking them to find them wives who would come to America. My mother came over, and they lived in San Francisco's Chinatown.

My father hardly ever talked about what it was like when he first came to the United States or what his childhood was like. One time, many years later, when we took him to the wine country [Napa Valley], he began to wax nostalgic, and he said that when he first came here, he went to the wine country and picked grapes. They took so much for his room and board that he hardly had any money at the end of the week. He had hoped to send money back home because my father always sent money to people in Japan, even though he was so poor. He deprived himself. He gave money to his family to alleviate their poverty. But part of it was that he was proud to show he was doing well in America—even though he was a farmworker and not making much money. He was a farm worker, mainly in Walnut Grove and that whole area below Sacramento. He said so many of the Japanese single men would gamble and drink and go whoring around on Saturday nights. My father must have been a drag. He said to them, "Don't do that! Save your money, start a business, get married." He used to hold onto their money for them so they wouldn't spend everything. He was like the banker.

My father leased a three-story hotel in Chinatown, on Clay Street, because the Japanese could not own any property, including hotels or housing of any kind. He brought up all seven of us in this hotel. It was called the Kitano Hotel; my family name was Kitano. Most of the people there were primarily black people who were on welfare; a lot of them were single men who used to tell us stories and were very kind to us. There were also Japanese bachelors living in our hotel. There was Mr. Baba who was just exceptionally close to our family; he was like an uncle. He'd tell us stories that I still remember; they were very vivid. He also told us ghost stories that were really scary. I could still hear his ghost stories scaring us to death. On our way to school, we used to have to pass a black church. Somebody told us that there were spirits in that black church of people who were unhappy and would catch you. So we used to—people must have thought we were crazy, little kids—go in front of that black church and run like mad to get to the other side. We also had some Japanese who worked in laundries and came in and stayed at the hotel.

The hotel was kind of elegant. The parlor, which was available to everybody at the hotel, had a marble floor and a great, big mahogany table. My father read the newspapers out there, and people in the hotel would sit around and talk. There were plants all around the parlor, and I remember my mother hovering around and caring for them. We kids didn't really participate in the upkeep of the hotel. I was the fifth girl, so a lot of the work didn't hit me. We had our own rooms that we had to clean. We did help my mother with the scrubbing, washing, and ironing when we were little. One of our responsibilities, when the telephone rang and we were eating dinner, was to take turns running upstairs and ring the doorbell of the person who got the call. My father and mother did all the work, and then my sisters took over when he was picked up after Pearl Harbor. That was the first time they had to do that kind of work at the hotel. And they talked about how they hated making beds and

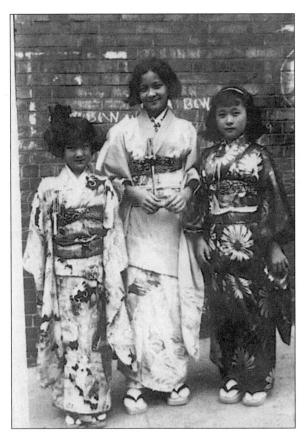

Chizu (on the left) and her sisters, Masako and Sadako, stand in traditional Japanese outfits outside the hotel her father operated in Chinatown in the early 1930s. (Courtesy of Chizu Iiyama.)

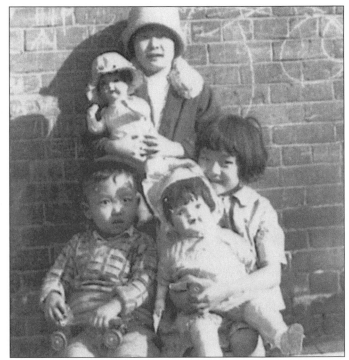

Chizu (holding the doll on the lower right) is photographed with her sister and a brother against the wall of the hotel in the 1920s. (Courtesy of Chizu Iiyama.)

changing sheets. The hotel used to have a lot of fleas jumping around because we lived in poor circumstances.

There were seven children in our family—five girls and two younger boys—and we were children of the Depression, which meant that there were many times my parents used to worry about food—whether we were getting enough. But my parents were proud that they never went on welfare. They came from a background where they, and Japanese immigrants as a whole, felt that they were going to be able to hold their own. We were so poor that sometimes for Christmas all we got was an orange. We were not that disappointed, and all of us took it very well. We knew that we were very poor, and we knew that papa and mama worked very hard. My mother and even my father sewed clothing for us when my mother was too busy. Although we were poor, we did grow up fairly happy. We had a cooperative family because, under those conditions, we had to. Looking back, my parents gave us a lot more freedom than we thought we had at the time. We were also fairly compliant, although I, probably of all the people in my family, was the most rebellious of my sisters. I used to pressure my parents all the time—why this would happen, why do they do this, etc. My parents were not too happy with me, I think. I was kind of a thorn in their side.

My father had a great temper, and I can remember that we children loved to jump on the bed. Once we broke the bed because seven children were jumping up and down on it, and my father was so mad. He was so mad he threw us down the stairs. We could have been hurt, but when you're young and you're a child, you bend easily, so none of us got hurt. Since my father had a very quick temper, we tried really hard to stay away from him because we didn't want to be the recipient of a slap or something like that. The other thing we did was jump on a broom. We'd jump up and down on the straw end, and my father and mother used to get so mad. My mother told us that if we jumped up and down on something like that, when we grew up and tried to have a baby, we were going to have a hard time. I could understand as an adult why they were so upset, because we were destroying property, and my parents had little money to pay for such items.

One of the things I really cherished was when my father used to take us out to Ocean Beach in San Francisco every Sunday; that was our favorite place. My father usually took my two brothers and my two sisters—five of us. My oldest two sisters, by that time, were too old. We went there on the streetcar because we didn't have a car of our own. I always wondered why he took all of us on the streetcar because sometimes we threw up and were not the easiest children to take care of.

We loved to go to Playland at the beach. My father would give us 5¢, and we had to figure out which ride we were going to take, and we always bought pink popcorn or pink cotton candy. We spent the whole Sunday going through the rides, having the food, and then rolling down those wonderful sand dunes until about five o'clock in the afternoon; then my father would take us home. When my husband came back to San Francisco several years after World War II, we took our children out there. There was a place at Playland called Hot House, and they had the best enchiladas. We were so disappointed after World War II when we came back and the Hot House was gone. We've tried enchiladas everywhere, but nothing tastes like the enchiladas at the Hothouse; they were so good.

We also went to Dead Man's Beach, near Ocean Beach and Sutro Baths and behind the Cliff House. We used to climb down the cliff and go to the beach and have weenie bakes. I think that Sutro Baths did not allow Asian kids, or at least didn't allow us to

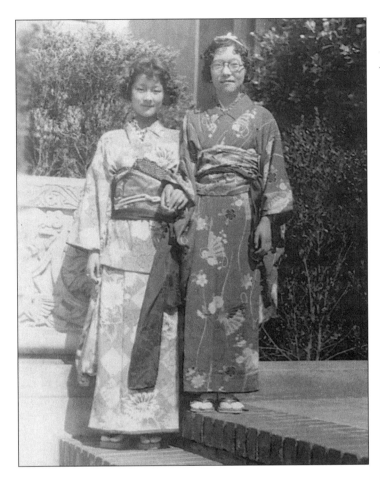

The teenage Chizu poses with her friend in the mid-1930s. (Courtesy of Chizu Iiyama.)

go swimming in that wonderful place. I do remember sitting out and wishing that we could go in the pools, as we were able to go inside to look at them but couldn't go in the water.

We also went to Golden Gate Park a lot, and we had family picnics. Many times, all the Japanese who were in the area would go. And we would have races and games. My father always wore this white outfit, and when we saw him taking it, we knew we were going to go on a picnic. We used to have what they called *kenjinkai* picnics, where people who came from the same area in Japan would meet. Before the YWCA, right near my father's hotel, was built, there was a big lot, and all of us who were Japanese-Chinatown people used to go there to play. It was just a real fun place to play. We built little fires, and we had weenie roasts and baked potatoes.

I went to Jean Parker Grammar School, which was mostly Italian at the time and was about eight blocks from the hotel. We usually walked to school, but every so often, we would save up our allowance of 5¢ a week, and instead of buying food, we would take the cable car. I remember the curves you had to go through, and you had to really hold on so you didn't fall off. Once, my lunch slipped out and fell off. Elementary school was fun for me, and I got a lot of praise there. The teachers were very good to us, the Japanese kids, because we tended to study and do well in school. We succeeded in the American school because we were told that was the only

38

way we were going to get ahead. We studied hard and pulled good grades, and many of us went on to college. One thing, though, the teachers kept saying to me, "We had your sister and she was really good." So I knew I had to live up to her reputation. We went there from nine to three in the afternoon. From three-thirty until five, we went to Japanese school. Japanese school was very difficult for us because we wanted to play, to be outside, to do a lot of things, but our parents insisted that we go.

One time, when I was in grammar school, the teacher had two tickets to *A Midsummer's Night Dream*, a Max Reinhart stage play with Mickey Rooney. She gave me one ticket, and somebody else in the class got the other. I was so happy because I'd never seen a stage play in my life. I wanted to see it so badly, but when I came home, my mom said, "No, you can't go!" And I said, "Why can't I? This was an honor the teacher gave me because I did well in school." My mom said, "You have Japanese school, you've got to go to Japanese school." I think I cried for over an hour. I sat there, and I had to force myself to cry. It's difficult to cry for an hour, but I cried for an hour. My mother never budged. I never used that tactic again. Never cried like that just to get my way. But I can remember being so frustrated because I had so wanted to see this play. And my mother insisted, and my mother could be very stubborn and very strong, that I go to Japanese school. I still think she made a mistake. It wasn't like I learned so much in Japanese school, anyway.

I think part of the reason we didn't learn is because it was a revolt against parental pressure. My parents tried very hard to keep us in touch with Japanese language, literature, background, and the stories they told us. We also took things like Japanese dancing lessons, and we used to do Japanese plays. This effort reflected their hopes that we would be Americans and partake of American life, but we'd never forget our heritage. But a lot of us revolted by not really learning and sloughing off in Japanese school. I wish today that I had studied more so my Japanese language would be a little better.

When I was a teenager, I went to dances sponsored by a Japanese-American organization. I don't remember going to any mixed events until my junior or senior proms. And even those, we went with a group of Japanese-American kids, and we danced among ourselves. We had a lot of difficulty with my parents when we were adolescents because they still wanted us to follow the old Japanese customs and traditions. A date in high school meant that somebody would call you up, or you'd meet that person at school, and he'd say, "How about going to the basketball game with me?" We had a Japanese-American basketball league, and many of our boyfriends were on the basketball teams. So we would go, and after the game we would go out to the ice cream parlor. We were all poor. Nobody had money, and so they couldn't even take us out to dinner. It was only when I went to college that I met some young men who had some money and who had cars. It was very innocuous, but it was lovely. We would organize our own social activities. At Galileo High we had a Japanese students' club with all kind of social activities. There was some dating and going to the movies. There was also a spot in Kezar Stadium, and I don't know the name of it, but we used to go there. We went to Oakland to a place called The Chimes for hamburgers after a party. There was also a nightclub, but I didn't go to that until I was in college. It was called Forbidden City. But we didn't drink any liquor. My father was very, very strong about no drinking, and so none of us drank—the whole family. Nobody drinks. No alcohol at all.

Probably the most fun I had growing up was in 1939, when the World's Fair opened on Treasure Island. The fair was like Disneyland, actually more than

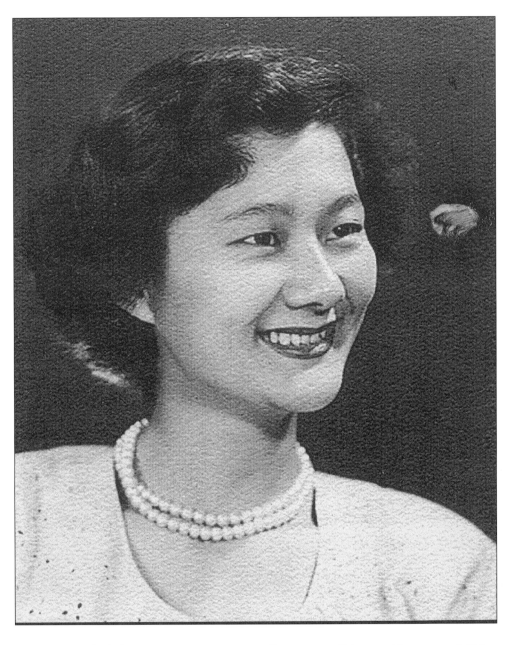

Chizu after she left internment camp in 1943 to go to Chicago. (Courtesy of Chizu Iiyama.)

Disneyland; it was really a magical kingdom. I was 16, and it was my first year of college. I'd graduated early, and I got a job at the fair. I worked in the Japanese Pavilion and in the commercial part in a little restaurant that gave me a real appreciation of what it must be like to be a waitress. It was so difficult to remember who wanted what. They had, it was like tempura, but they called it templa, and it was tempura in between two pieces of bread. We had green tea ice cream, which I loved, but never had before. They didn't really have Japanese food, not like they have today. I think it was more like fast food. They had a lot of sandwiches. I remember crab sandwiches were very, very popular. So it was not really Japanese.

I think I worked there for two years. I still remember the music that they played on the boat every morning as we took the ferry to Treasure Island. It was classical—my favorite—and it was such a joy. I met my friends out there and also got to know quite a few people, mostly Japanese-Americans who worked in the same area. I would tell my mother, "We have to work until ten o'clock in the evening." She must've realized I wasn't working all that time. I went to work in the morning and came home after ten at night because we wanted to see the big bands, which were so wonderful to hear. Basically a bunch of us went around to hear the bands, and it was such a crazy fair.

They had a place at the fair called Gay Way. Today we think, "My God, they called it Gay Way." It was a park with the rides and everything—synchronized swimming and shows and exhibits. They had Sally Rand and her Fan Dancers. She was partly nude but actually not really. It was just the illusion of nudity. She always had those fans in the strategic spots. There was also a woman named Zoe something, who was the queen of the fair and was so pretty. The lights at night were gorgeous, and it was a magical summer for me for two years. At the Japanese pavilion I was a guide, and I would explain about cloisonné (an enamel decorating process) and about tie-dyes and things like that. I remember showing the products and taking people around. I enjoyed that a lot, too, and really had a good time. It was at a time just before World War II, and there still was a lot of anger against the Japanese because of the incursion into China. But people were usually very nice.

The one thing I do remember with some sadness was that in 1940 the Czechoslovakian exhibit closed because the Germans went into Czechoslovakia. One by one, some of the exhibits closed because those countries were conquered by the Germans. I remember Czechoslovakia especially, but I don't remember some of the others. I wondered, "Gee, is this going to be the end of innocence, and it was." It was the end of that kind of glorious period of adolescence for me when I was 16, 17, and just enjoying life without having to worry about other things. I never thought about it at that time, but the outside world had begun to infringe upon our very cocoon-like existence in the Japanese-American community. That's why Pearl Harbor was such a shock. We just got the feeling that it was the end of an era. It was the end of an era for almost everybody. And when we talk about the fact that the evacuation during World War II was a defining event for Japanese Americans, World War II was the defining event for so many people because it changed their lives completely. Guys had to go into the Army and fight, an experience that was so totally different. I remember as a kid seeing the pictures of World War I in the Hearst press, and I was fascinated by seeing a war, but never thought it would ever happen again. Unfortunately mankind keeps doing that over and over again. But it was under the gaiety and the magical part of the World's Fair that I realized that outside Treasure Island, outside our Japanese community, things were happening.

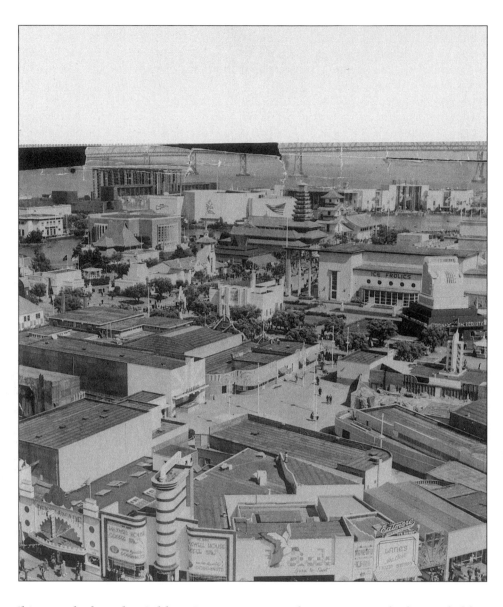

Chizu worked at the Golden Gate International Exposition, which was held on Treasure Island, from 1939 to 1940. (Courtesy of The Anne Thompson Kent California Room, Marin County Library.)

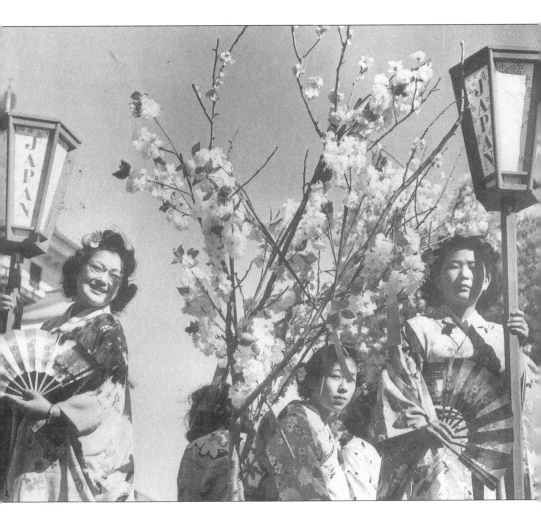

Three women, adorned in traditional Japanese garb, stand under the cherry blossoms at the entrance to the Expo's exhibit on Japan. (Courtesy of the San Francisco History Center, San Francisco Public Library.)

The first indication of trouble occurred when Japan attacked China in 1936. The relationship between the Chinese and the Japanese for a long time was very good, until the Japanese invasion. We had Chinese friends, and we lived in Chinatown. In fact, there are some Chinese neighbors we occasionally hear from today. But when the war came, when Japan invaded China, just everything went really funny. The Chinese kids began to ostracize us or call us names when we went by. We still remained friends with some of our Chinese friends. High school was the first time I began to realize that there was discrimination against Japanese and Japanese Americans. We were never part of the mainstream and were always isolated.

I remember that at Galileo High School, because I was bright and used to do my homework, some of the Anglo kids would ask me for my homework so that they could copy it before they sent their work in; I would let them use my stuff. But it always used to gripe me because they would not even recognize me when I'd see them in the hallway. I'd see them, I'd smile, and I'd get no recognition, yet they were using my homework. I can remember that the basketball star, I was so pleased because he came to talk to me, but all he wanted was to borrow my homework. But when I'd see him with his pals, he didn't pay any attention to me at all. Those slights hurt, but I was used to it. At that time, I was willing to be used just to get a little feeling of being important in some way. But we had a very good Japanese community. And the community, in a sense, reinforced what my parents were telling us about our culture, giving us a background about what it was like to be a Japanese American. They talked about how important it was that we show white people that we're better than they are and stuff like that in order to give us some incentive, I guess.

My whole world fell apart in 1941 when Japan bombed Pearl Harbor. My father had been very close to Japan. He could never become a citizen of the United States; he was from Japan, so he was very nationalistic. Japanese leaders were taken away right after Pearl Harbor—December 8th and 9th. Throughout the country, the government picked up 2,000 Japanese Issei (first generation) men and a few women who were teachers. They took away teachers, people who taught martial arts, Buddhist priests, and the leaders of the community. My father was very active in the Japanese community. He was the president of some organization, so he was taken away during the second batch. While all this was happening, I didn't know if I should stay on at the university—the University of California at Berkeley. It was my last year. I was 16 when I'd started college, which was really too young. I was skipped several times while I was going to grammar school because I was doing well. Two of my sisters who were married by 1942 persuaded me to stay in school. They said, "You really need to stay in school and see if you can get your diploma." There was a really good administrator, Dr. Deutsch, the vice provost of the university, and he called all the Japanese Americans to a meeting. He said, "Stay in school for as long as you can. Your education is going to be very important to you no matter what happens. Remember you do have the rights of American citizens because you're American citizens." Some of my friends went back home because they lived in isolated farm areas, and they were worried about their parents. Those of us who were in the Bay Area generally stayed in school because we were commuting. There were instances where Japanese people were shot at after Pearl Harbor. It was a difficult period for all of us.

Then came February 19, 1942, when President Roosevelt signed Executive Order 9066, which eventually sent us into the camps. Actually, it was an order in which the Army was told to take away people—Japanese who lived on the West Coast—and

they had certain demarcation laws. There was also a curfew time and rules about how far away you could go without permission. I'm sure that where I lived was more than 5 miles away from the Berkeley campus, but we came to the school until April. It was on my sister's birthday, April 7th, that we were told that we had to leave, that we were going to be sent some place. But we didn't know where we were going, and we didn't know how long we were staying. We didn't know what conditions we faced. We didn't know what was going to happen to us afterwards. I think that anxiety was just really difficult because there was no information from the government. We were just told to pack up and go. And we could only take two bags per person. So my mother went out to the 5 & 10 and bought us suitcases for the first time. But they were cardboard boxes like suitcases, and we each had two of them. I know that she had a big argument with my brother because my brother was a teenager, and he wanted to bring his trombone. My brother was a real jazz fan, so he wanted to bring it. My mother said, "How can you carry your trombone and only take one suitcase?" But he only took one suitcase.

The story of the trombone is really interesting because when we got into camp, we put together a jazz band, so my brother got to play. And then when we went into our permanent place in Topaz, Utah, he was able to get out because the white kids invited my brother's dance band to play at their proms. Most of the Japanese in the Bay Area were sent to Tanforan, a converted horse track about 10 miles south of San Francisco, but we were sent to Santa Anita, a racetrack outside Los Angeles. The government wanted to start the evacuations right away, and Tanforan wasn't ready. I was able to leave the camp in 1943 because the city of Berkeley, with its strong core of liberal people, initiated the Nisei (second generation) student relocation program so that those of us who were going to college had opportunities to finish in the eastern parts of the United States. I think the American Friends' Service Committee and the ACLU [American Civil Liberties Union] got other universities across the country on board. The city and Cal [the university] got the scholarships and made the other arrangements for us, pushing the idea of getting Japanese-American college students back to school away from the West Coast. When we left camp at that time, we were told, "Don't speak Japanese, don't get into groups of more than three—just don't call attention to yourselves because it will jeopardize the whole relocation program."

One of the non-Japanese men who lived at my father's hotel stands out because of what he did when my father was taken away. Mr. Pearson, an older black man, said he would take over so that we didn't have to worry about the hotel. Mr. Pearson paid off the lease money—whatever we owed to the owners of the hotel. I remember Mr. Pearson with a lot of fondness; he used to treat us very nicely and very respectfully. I think that that's what we found with almost all the people in the hotel. He must have been either retired or on welfare, I don't know, but he lived in the hotel. He managed the hotel while we were away, so we felt that he was trustworthy—and he was. When my family came back at the beginning of 1945, the hotel still was available. Mr. Pearson was very gracious about his management, and my father was very grateful to him for all he'd done.

Michael Killelea, a lawyer for the city attorney of San Francisco since 1962, relaxes in his office in September 1999. Mike was in City Hall in 1978 when a disgruntled city employee, Dan White, murdered Mayor George Moscone and a city supervisor, Harvey Milk. (Photo taken by Steven Friedman.)

CHAPTER THREE
MICHAEL KILLELEA

I hadn't met Mike prior to our first interview in his office. He immediately greeted me with a warm smile and a firm handshake. After our two sessions together, I couldn't help but admire him. He is a praiseworthy man who is motivated by a love of family and of God, a desire to honor his ancestry, and a profound respect for the law. He might be the quintessential guy next door. His adherence to such traditional values as family, church, and country could seem outdated to the casual observer. But I found Mike's willingness to let his past guide him throughout life to be an idealistic leap of faith that is heroic. I also learned from Mike's recollections that one of the most important values he's adopted has been his unyielding humanity—how he accepts people from every background on the substance of their character.

The path of Mike's life has followed a fairly straight line—just the way he's liked it. He was born in 1931 and grew up in Berkeley during a much more innocent era. He was a neighborhood paper boy for ten years; was active (and still is) in the Catholic Church, having started as an altar boy; lived with his parents through college; went to a high school and college run by the Christian Brothers; went to a Catholic university for law school, the University of San Francisco; stacked cans and worked at the post office to support himself during college; served in the Marines; married his law school sweetheart, Peggy, a San Francisco native and a nurse who is also the child of Irish immigrants; raised three boys with his wife, much in the manner of their youth; and worked for the City Attorney of San Francisco for 37 years, before retiring in June 1999, though he still works there part-time. He is still friends with many of his teenage and college buddies. The best man at his wedding, Bernard Cummins, was a classmate from high school. When Bernard got married, Mike was his best man.

Mike recalls, with a gleam in his eyes, the uncomplicated times of his boyhood, when families survived without TV or computers. "We were a close family," he said, "and everything was centered around family life. It was so enriching for me to be raised with our Catholic faith and our family values." He feels that this simpler life was a natural boost to family cohesion. Much of his family's entertainment involved the entire family—his parents and a younger sister, Patricia Killelea Springer. Among the activities they enjoyed was sitting in the living room listening to shows such as Jack Benny, Fibber McGee and Molly, Lum and Abner, *and* The Lone Ranger *on the large radio. Mike also recalls vividly how he and his sister shelled peas on the porch on Sunday afternoons. There weren't frozen peas in those days, and it was their duty to shell the peas to accompany the traditional Sunday evening meal: leg of lamb and baked potatoes. When he wasn't with his family, he was with his friends, playing ball in the neighborhood or delivering newspapers.*

His reverence for his background, his beliefs, and the myriad of people who have touched his life, especially his family, shine through most of his memories. He absorbed and adopted a core set of values that were affirmed at home and in the church, in part because of the pride he felt about his heritage as a first generation American whose forefathers and foremothers came here for better opportunities. The religious training he received at home and in church was another way for him to identify with his ancestors.

At the age of six, Mike sits atop a horse near his home in 1937. According to him, this was a commonly photographed scene for that time. (Courtesy of Michael Killelea.)

My parents, Patrick and Nancy Killelea, were immigrants from Ireland. They met in Ireland, married in Ireland, and immigrated in 1929 to Oakland, California, where my father had three uncles. They felt that life in America would be better for them to raise a family, after my father's uncle communicated with them about the opportunities here. My grandparents never came to the United States, so I never saw them. Never even talked to them either because at the time my father got married, his father and mother were deceased. My mother's mother died shortly after she was born, and her father was the only grandparent living. I never talked to him, but we wrote to him. He never came to the United States, and we never went to Ireland, so I had no immediate grandparents, and I always used to marvel how a lot of my classmates would go to grandma and grandpa's house. I always thought that was a very nice thing to have a family like that. My father had a brother here, Thomas Killelea, who was a bachelor. He worked for Union Oil Company, and at that time, the company had dormitories for some of their unmarried workers. He lived there, and he loved it because he was with other fellows like in a dorm set-up in college. He lived there until they took out the dormitory, but he continued to work for the Union Oil Company until he retired. My dad's three uncles lived in the Bay Area, but they were deceased by the time I was just a child.

My dad worked for Durkee Famous Foods in Berkeley. They made relish and salad dressing, but their primary product in Berkeley at the time was mayonnaise. My dad was looking for work as a new immigrant, and he saw that they were building this brick building down in west Berkeley as a factory, so he applied to work there. He worked there for many years and became a pasteurizer of milk. Officially, he worked at Durkee as a butter-maker, which is what they listed as his profession on my birth certificate, but he was actually a pasteurizer of milk. Durkee Famous Foods is no longer there; they relocated.

The first home that my parents had was near Berkeley in Albany, on Ramona Avenue between Santa Fe and Solano Avenues. My parents rented that home. Then we moved when I was ten years old to 863 The Alameda, the home I was raised in. The house was a large four-bedroom home built on a hill, about 1920, with a beautiful view of San Francisco. My room was upstairs, and there was a front bedroom from which I could see directly to the Golden Gate Bridge of San Francisco and Marin County. The house is on the east side of the street, and the hill starts at The Alameda, and it goes all the way up into the Berkeley Hills, up to Grizzly Peak Boulevard, which is right at the top. My sister still lives there with her husband. My father fortunately saw it one day in 1941 for sale, and he purchased it. It was a wonderful investment that he made because it was just a beautiful home in a nice middle-class neighborhood with many children that I went to school with. It is in north Berkeley, in the Thousand Oaks district, at the head of Solano Avenue, where Solano comes to a T with The Alameda.

I got to know many of the neighbors quite well, and some of their children are still my friends. Meeting people was easier because I delivered newspapers to that general area. I had a newspaper route for ten years for the *Berkeley Daily Gazette*. I had the route all through grammar school, high school, and a portion of college. I used to come home from St. Mary's College and deliver the papers in a half-hour. It was a daily paper, but we had to collect once a month, and people paid the paperboy; they didn't mail in a check. Since I had the same people for ten years, I got to know them and their families, and I saw their children, who might've been ten years old when I started, become twenty years old when I finished. And so I grew up

there, too. I had about a 106 customers, and I got to know these people like family. When I went to collect, people said, "Well, why don't you come in?" Then we'd have a cup of hot chocolate or a piece of pie or cake, and I'd sit down with the family for a minute before they'd pay for the paper. It was a great experience because I had older people, some lonely, and maybe they wouldn't see many people during the month, but I could visit them. Many would send me gifts for Christmas or when I graduated from high school or from college. They'd still remember me, and we remained friendly years after I finished my services as a paperboy. Many were from different cultures and age groups, so it was a very rewarding experience for me when I became an attorney. It helped me in knowing people.

The *Berkeley Gazette* was a daily paper that most everybody got in the afternoon. It was a six-day paper, which meant it was delivered on Saturdays but not on Sundays. I would come home from school, and then I'd go up to the corner of Los Angeles and Contra Costa Avenues, where they delivered the papers in bundles. We'd meet there and fold the papers, putting them in paper sacks that we carried on our routes. All the guys with their different routes would meet there. We used to play football everyday in the street while we waited for the papers to come. Two of the guys, Mark Buchanan and Bob Donovan, were classmates of mine at St. Mary's High School, and we still are good friends. Sometimes my sister, who was four years younger than me, used to enjoy going with me. When we delivered the paper, usually we could toss it. For certain people, aged people or people that I recognized couldn't get the paper by going down the stairs, I would give them special service because I thought of these people as friends. It wasn't any extra effort for me, but yet it helped them out. I kept the route through high school and college because, by then, I could do it so quickly that it didn't intrude on my time. While I was in college, I lived at home and of course while I was in high school too, so I could deliver the papers in a matter of 45 minutes. I did it as much for the enjoyment of meeting the people as I did for the income I was making.

I also had time to enjoy activities outside the paper route, which I didn't get until I was ten. One of the big things to do when I was younger was to go downtown to places like Woolworth's or Kress', and you could buy nearly anything in these stores. They always had counters where they would serve food. They were not restaurants so much as they were long marbled counters and soda fountains and round stools you'd sit at. I don't remember getting an allowance, though I'm sure my parents gave us one, but when I started carrying papers, I didn't need it. So in those days, you'd feel very important if you could order a Coke in the bottles, the traditional Coke bottles, and then buy a chocolate sundae with marshmallows on top, or get a vanilla ice cream soda. When I was a child, the big thing for us was to go to one of these places and get a hamburger and a milk shake. These places served this magnificent hot food, and it was just so good. You could get meat loaf and gravy and potatoes. And this was quite a treat. If I went down to the Tenth Street Market as a young child, for example, this is when we'd stop off at Kress', and I'd sit at one of these counters and have a meal with my family. They had a Kress' here in San Francisco on Market Street as well as a Woolworth's. And they had a Kress' in downtown Berkeley on Shattuck Avenue and a Woolworth's in the same area.

There was an ice cream store on Shattuck Avenue in Berkeley called McCurdy's. We went there a lot for hamburgers and milkshakes. We also went to Bolton's Drugstore, which was owned by a woman who must be in her nineties now and lives across the street from my sister. Her husband was the local druggist. In the drug store

Mike receives a watch in the early 1950s from representatives of the Berkeley Daily Gazette, *for his ten years of service as a paperboy. (Courtesy of Michael Killelea.)*

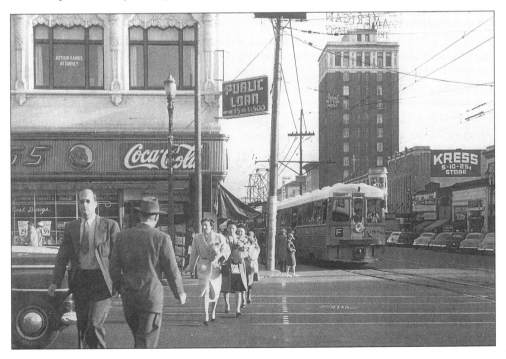

This view shows the downtown Berkeley shopping area at Shattuck Avenue, with Kress's located to the right. (Courtesy of the Berkeley Historical Society & Museum.)

was their fountain with this marble top, and that was the place we'd often go. We'd also go down to Larsen's Bakery to get bakery products. My mother would send us down there to get some fresh bread. You could smell the bread being made there, and you'd just run down; it was only across the street. Or, sometimes, when we went to Larsen's, we'd like to get some of their delicious cake. We kids wouldn't buy cake for ourselves, but we'd urge our parents to buy the cake. Then they would buy this beautiful cake, and we'd have that as a dessert. That was a big treat. We used to go down the street, and the donut guy would throw flour up against the window when he was making the donuts, and we thought that was really something. For a big treat, we'd buy a couple of donuts.

In downtown Berkeley there was a department store called Hink's, owned by Lester Hink. Hink's was a smaller version of stores like Macy's, Capwell's, or the Emporium. Hink's was a family-owned store. I remember walking in there, and the floor was hardwood. It had great clothes, all kinds for children or for adults, and you could buy anything. They closed 15 or 20 years ago, but it had been a mainstay of downtown Berkeley and Shattuck Avenue, and it was within walking distance of the University of California campus, which dominates downtown Berkeley.

People who were native to San Francisco remember the Crystal Palace Market at Eighth and Market Streets. They had a similar one in Oakland, near Berkeley, called the Tenth Street Market. The market had a shop that was just set up for selling apples, another one for sandwiches and pastries, and another was selling just hams or sausage. These stands at Tenth Street Market were permanent and were every day of the week. I loved going there with my dad and mom because of all the different things that they'd hand out. They had a Riley's ham and sausage shop, and there was a lady there who used to give out these free little sausages that she cooked as samples on toothpicks. Even after I became an adult, I used to go there. When I was in the District Attorney's office in Alameda County, I used to bring home food to my wife and family. And I'd bring things to my parents, too. Mostly I remember going to the Tenth Street Market with my parents, and my sister and I weren't there so much to wander around and buy things, as we were there to be with them. My parents would give us a small amount of money to buy candy because they had a candy shop.

It was just an experience to go down there. We didn't have a car, so we took public transportation. We'd take the bus down or the trains from downtown, or from north Berkeley where we lived, and we'd purchase things and bring them back home. It was the sort of place where you didn't shop every day because it was too far away. But it was a place that you could shop once every week or two and go down there because you'd get all these great fresh products. My parents would go down there to buy different things because we didn't have freezers then. We just had refrigerators, so we'd go to the various markets quite frequently.

Another one of the stores, that was just starting at that time, was the Park N' Shop Market, which is now called Andronico's. It was just a little local store then, but now it's grown into a pretty large chain. There's one in downtown Berkeley and San Francisco and Marin County. The founding place was on Solano Avenue, which was just a two-minute walk from the house. My mother would send me down to get groceries, and I have a vivid memory of bringing the ration book with me because it was wartime. The ration books had different types of tickets for butter or eggs or other products, and I had to bring the ration stamps to Mrs. Andronico. The train used to come in right next to Park N' Shop, and there was a terminal right there.

There's a tunnel there now that you can drive through. It used to be only for

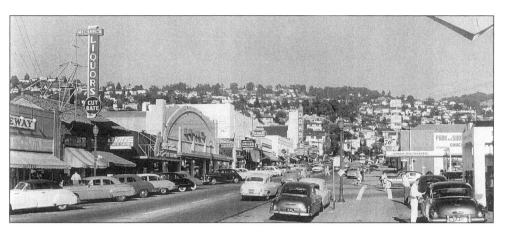

A wide view of the downtown Berkeley shopping area shows Bolton's Drugstore, situated toward the hills halfway down on the left. (Courtesy of the Berkeley Historical Society & Museum.)

trains, and the big excitement was to be able to walk through the tunnel while the train wasn't there. That was very risky conduct, but you knew when the train had gone so you could run through the tunnel. Now you drive through it, and it takes you from one end of north Berkeley right into Berryman Avenue and right up to Shattuck Avenue by St. Mary Magdalen Church.

Another very special time for me was the 1939 World's Fair in San Francisco at Treasure Island. My mom and dad used to bring me there, and I remember the place where they manufactured Ghirardelli chocolate in a big churning machine. Then there was the swimming and the aquacades with the glamorous water displays and neon lights. They had a demonstration where you could actually walk through a mine as if it was in one of the mining states. It was dark with figures of miners and what they'd be doing, and it was sort of a demonstration of Americana—a glimpse of how life is lived in the United States.

We did other things in San Francisco as well. Before the Oakland Bay Bridge, we had to take the ferry into San Francisco from Berkeley or Oakland. The ferry would have its whistle blowing, and it would just about make you jump right off the deck. Then you'd dock at the Ferry Building and get a streetcar. After the Bay Bridge was built and then opened in the 1936, we'd come to San Francisco on the F train. It used to stop on the corner of Solano Avenue and The Alameda, and then it would go across the bridge. There was an area for trains on the lower deck of the bridge [the railroad tracks have since been removed]. Often we went out to the zoo, and when we got some distance west of 19th Avenue, there were just sand dunes the rest of the way toward the beach and zoo. At the zoo, I went through the different areas where they had the elephants. I was fascinated by these large animals and also by the lions. I'd see these grand animals that you'd read about from all these foreign countries. Every summer we'd go spend the day there, and it was just a wonderful feeling to be with my parents and sister. Out by the zoo, near 48th Avenue and Sloat Boulevard, was Fleishacker Pool. It was a large open-air pool with salt water that was pumped in from the ocean. I remember going out there, and you could look from one end of the pool to the other and hardly see the other end. People would go swimming there

53

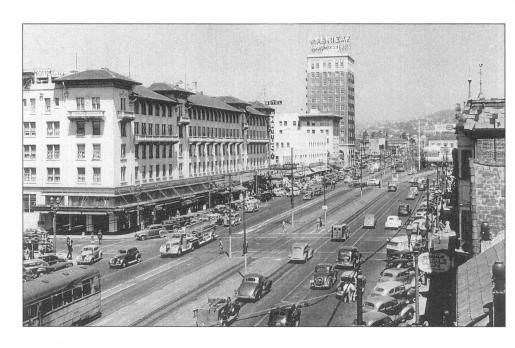

In this shot of downtown Berkeley in the 1940s, Hink's department store appears at the top left. (Courtesy of the Berkeley Historical Society & Museum.)

even if it were foggy, cold, or windy.

As kids, all the way through high school, we played a lot of ball. There's a park near our church, St. Mary Magdalen, called Live Oak Park, and we used to play basketball there. We also played basketball, baseball, and football at St. Mary's College High, the all-boys school where I attended high school, or on one of the public school grounds. If we played sports, it was self-organized. Every Thanksgiving we would have a self-organized football game called the Thanksgiving Bowl at St. Mary's High. There were no adults, and we had our own rules and regulations that we'd fight about if someone went out of bounds or whatever. There was one family called the Reed brothers, and they were very aggressive football players. They'd divide the teams up, and the brothers were on different sides, so they'd select the rest of us to be on one of their teams. Basically, our lives were taken up mostly with sports in those days; there wasn't much else to do, but we were totally satisfied. No one seemed to have a car, so we were mostly with other guys playing ball.

Our church had a youth club, the Caloraga Club, where we had organized activities. Maybe we'd go to the snow together, or there'd be dances where the boys would stand on one side and the girls on the other. Then the boys would go out afterwards and play some ball. In those days we really didn't date—not because we didn't like young women. It was just that we had so much interest in playing sports. Of course we went to the junior prom or senior ball because that was something of an event to which you should go. And we enjoyed them. But to go to the junior prom, to have to pick up the phone and call up some young lady, that was a big event. I had to rehearse that for days and days.

Besides my family, probably the biggest influence in my life, has been the Christian Brothers. The Brothers were instrumental in my education. They taught basic

education and religious education in a humble way and a very strict way, which we young teenagers needed. St. John Baptist de la Salle founded the Christian Brothers in France to teach poor students who would not otherwise receive an education. They're not priests, but they are dedicated to God and the Church. They teach at all levels from grammar school right through college. They came to California in the 1800s. St. Mary's College was actually founded in San Francisco at St. Mary's Park, and later moved to Oakland. In 1927 the college moved to Moraga in Contra Costa County, about 45 minutes east of San Francisco, where it's presently located. The high school has been around for the same amount of time and is located in North Berkeley right next to Albany. I was so impressed with some of the guys who went to St. Mary's High, some of the guys I played ball with in the neighborhood, that I asked my parents if I could transfer there. I walked down there one summer afternoon, and the vice principal welcomed me and said I'd start a week from the following Monday.

Our principal, Brother Ralph, was a very strict person. If we were late to school, you might have to stand in the hallway for an hour or have to kneel and hold out a Bible in your hands. Once, one of my classmates left school early with two of his buddies. They went on one of the local buses and thought they were going to skip school. Brother Ralph drove up behind the bus and saw them at the back window. He stopped the bus, then went up to the three boys and said, "off the bus." The next day he drew a round circle with chalk in the schoolyard. He told them, "You are going to stand in that circle for the next two weeks, and nobody's going to talk to you. And if you leave, you're going to be punished further." He wanted to demonstrate that that was going to be their punishment for leaving school early. But he was a very caring person. Sometimes he would take the football and just throw a spiral downfield that went 50 yards—straight. There was a rumor that he was an All-American athlete from Boston College. He did have really large hands.

People were creative in trying to outsmart Brother Ralph. Guys used to go down to the gully behind school to smoke. Of course, there was a no smoking policy at school, so one time Brother Ralph hid in this old tool shed and greenhouse because he wanted to pop out and catch the people down by the gully. We called Brother Ralph "The Brow" because of a character in the comic strip *Dick Tracy*. The Brow was someone that had all this furrowed baldness across his forehead from frowning. Brother Ralph also had no hair, so we referred to him as "The Brow." Well, the custodian put up a sign, "The Brow's in the greenhouse." So we all came out and said, "Brother, how are you doing in there?" Guys were throwing rocks at the greenhouse and saying, "Do you want to have a cigarette, Brother?" Finally—it was so embarrassing—someone locked him in it. After we went back to class, they let him out of the greenhouse, and he had to return to school.

I really appreciated my Christian Brothers education. I thought to myself, Wow, I'm entering an era in which I really appreciate not only the friendships with my colleagues, but also the Brothers who taught me; it was very sad leaving them. I continued my education at St. Mary's College, which was also established by the Christian Brothers. They fostered a feeling of strictness along with grounding to your faith, following true to what your responsibility was, and being responsible to your God and your family, your friends, and your community. We have continued to have friendship and bonds between us. Once you meet a Christian Brothers graduate from another school, there's an immediate bond. That's in large part because of the Brothers and their devotion to teaching and to the Church. I have actively continued in support of the Christian Brothers and their educational and religious goals.

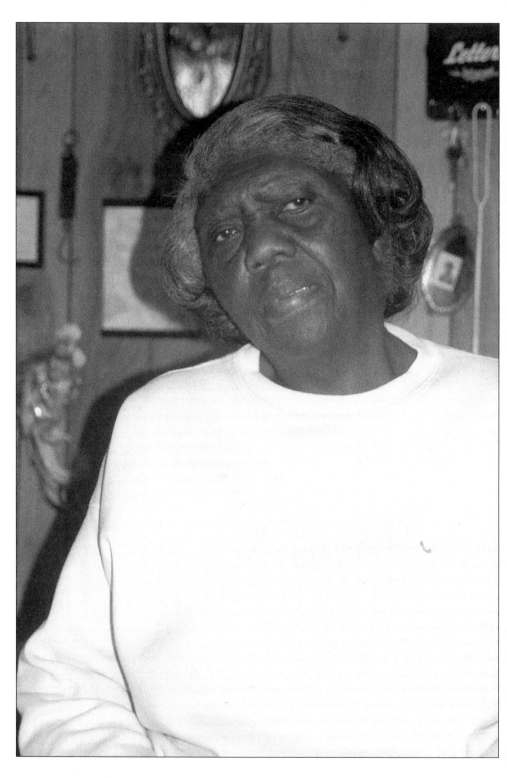

Nora Lee Condra is pictured here in September 1999. (Photo taken by Steven Friedman.)

CHAPTER FOUR
NORA LEE CONDRA

When Nora Lee Condra prepares her annual Thanksgiving feast for more than 70 members of her family, she has one rule. "I always tell them not to bring nothing that is store bought. If you can't make it, go find somebody that will make it from scratch." Because of her cooking and quilting, Nora Lee is a local celebrity and matriarch. She has 7 children, 22 grandchildren, and 14 great-grandchildren, so she starts baking the last week in September. By the time the holiday comes, she will have made 13 cakes and a dozen pies. There will be three pound cakes, including a buttermilk pound cake, sweet potato pie, coconut pie, apple pie, and her legendary peanut butter icing cake. "Thanksgiving is my day to celebrate with family and eat country food."

She learned to cook from her grandmother in Granada, Mississippi, where Nora Lee was born on December 15, 1919. Granada, about 95 miles southeast of Memphis, was much more racially tolerant than the Deep South. Her father rented a farm there and had 45 acres of land, where he raised corn, cotton, peas, beans, tomatoes, potatoes, peanuts, cows, and horses. She was a terrible cotton picker, but she could cook like nobody's business. "Cotton picking, I couldn't do that. I'd go crying to my daddy, and he'd tell me to go to the house and cook dinner." She started when she was eight, baking cakes, and by the time she was 13, she was making chicken and other main courses for dinner. Cooking is such an integral part of her life that Nora Lee only needs her nose to tell her if something is wrong on the stove. "A lot of times you don't have to taste it; I can smell. Sometimes I'll just get an odor from your kitchen, and I'll know if something in there ain't got enough salt or pepper. That's what they call a cook. That comes from way back, from my grandmother. One time she walked into my kitchen and said, 'Lee, you don't have enough salt in the—what is that you cooking? Greens? Put a little more salt in it, another pinch.' She was right. It smelled too fresh."

She arrived in Marin City in 1949. The town, with its sparkling view of the Golden Gate Bridge, the bay, and the San Francisco skyline, began in 1942, after Bechtel was awarded a contract to build the Marinship Shipyard in nearby Sausalito. Workers from the South and Midwest were recruited, and temporary housing was constructed in Marin City. The population reached a war-time high of 6,000 in 1944. When the shipyard closed after the war, most whites left Marin City, while most blacks remained. The vicious coupling of racism and almost non-existent economic opportunity gave black people few options. After two failed marriages in Mississippi, Nora Lee settled down in 1952 with George Condra, who had come out here from Arkansas to work at Marinship. They were married nearly 33 years before his death on the last day of 1984. She was employed on and off as

a domestic worker, while she raised her family, until the 1960s.

She is a deeply religious woman who reads the Bible everyday and attends church regularly, and is devoted to her family. She brought both her grandmother and her mother to Marin City and cared for them in their final years, though not at the same time. She also takes care of some of her grandchildren and great-children each weekday afternoon during the school year. Several years ago, she stopped preparing the family's Christmas dinner because her brother and husband died during the holiday season. With a little bit of her happiness gone, Nora Lee couldn't summon up the energy after Thanksgiving to cook another feast. The year after their deaths, she planned to stay at home—alone. But she raised her children well, and they did the same for their kids, so they brought her to the Christmas meal at her youngest son's home in Vallejo. "'Modear,' that's what they call me, 'we all miss Papa.' That's what they called my husband, George, or some of my children called him Big Daddy. They said, 'We all miss him so.' They knew I was lonesome. It was a sad Christmas that first year after he died because it seemed like he should have been there. Finally I told them that I wasn't sad but I just missed him. We ended up having a wonderful time, and we stayed over into the night." That evening, Nora Lee helped to usher in a new holiday tradition. Now each of her children takes turns hosting the Christmas meal, and believe it or not, she lets them prepare just about everything. As long as it's made from scratch.

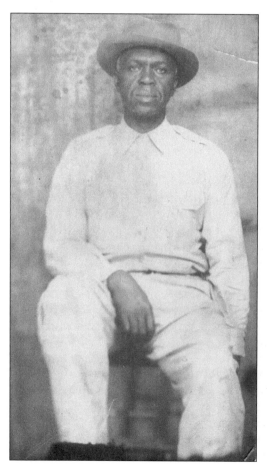

Pictured here is Mrs. Condra's father, Columbus, a tenant farmer who also loved to hunt, fish, and trap animals. (Photo courtesy of Nora Lee Condra.)

Although the developer initially promised fancier homes to Marin City inhabitants, residents dubbed the final offering "pole houses" because they were built with telephone poles. The county newspaper took this photograph of a local resident, Mrs. Moses Brand, outside a home under construction in 1962. (Photo courtesy of the San Francisco Public Library.)

I came out to California the first of '49, because my baby brother was in the service out here at Hamilton Field in Novato. Every time he'd go overseas, they'd bring him back to Hamilton Field because he was the chief cook there. They liked for him to cook out there at Hamilton. He could cook. And that's how I got here. After me and my second husband separated, my brother came back home and asked me, "Would you like to come to California?" and I said, "Yes." He said, "When I go home, I'm going to get a bigger place, and I'm going to send for you." So he did. Me and my baby brother was very close. When I first moved here, we lived at A63 Drake Avenue, an apartment, in Marin City. It was the wartime houses, the little brown houses with the green tops. I had a room with him and his wife. The apartment was nice because the front of it had a little closet when you stepped in the door. And then you had a couch, you had chairs, but in between was the kitchen, a little kitchen, then the bathroom, then you go right through the kitchen to the back rooms, and on the side there was a bathroom. I slept in the front room. The couch would let out, and I'd sleep on that. In the daytime I'd fix it up because it was a couch, and at night I'd let it out and go to sleep. In those days, you could leave your doors open, go all the way to San Francisco, and your door still stayed open unless it was going to rain, and the wind would blow. Then somebody would come and shut the door, but they wouldn't bother nothing.

When I first came out here, I wasn't working. Then I'd go and work at different peoples' homes and help to serve parties. I helped to serve parties over in Belvedere, over in Ross. Then I finally got a steady job doing domestic work. I wouldn't say

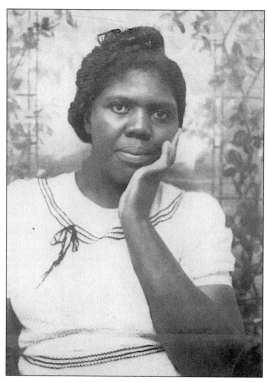

This picture shows Mrs. Condra in Granada, Mississippi, in 1942, when she was 23, married, and had begun working as a domestic. Within a few years, and with three children to support, she took another job at a local barbecue pit. (Photo courtesy of Nora Lee Condra.)

Today Marin City is still primarily African American. Community pride is resurfacing with a spate of projects and growth, including new townhouses, a major shopping center, and a photo exhibit showcasing Marin City's greatest resource: people of all ages from diverse backgrounds. (Photo taken by Steven Friedman.)

domestic work, because after seven or eight months, I was seeing after Mr. and Mrs. Ramsey's son, and I would give him his breakfast and his lunch because he had polio. She was working at Emporium over in San Francisco, and I'd make her beds and then kind of dust around; I kept everything nice and clean. Sometimes if she needed something done, she'd tell me to bring my baby over because she had a baby there, too. I'd take her there with me, sometimes, because Mrs. Ramsey was kind of ill at the time. I'd take my baby over there with her baby, and she'd put them in the bed together. And I'd work a little while. Wasn't too much to do because she just wanted company. I'd be there working and dusting. Meanwhile, the babies are sleeping. When the babies wake up, then me and her sit down and have a cup of coffee, feed the babies. I enjoyed that because she didn't have a sister, and I didn't have a sister, so we was sisters together.

I got the job with the Ramsey's because one of my friends used to work for them, and she wanted to go and get more money. She started working at the pressing shop over in Tiburon. So she gave me the job at the Ramsey's, and that's why I was there. I was working for the Ramsey's by 1950, and I worked for them for 26 years. I only took a break for a month in the early fifties when I went back to visit my family. I went back to see my five children and visit my mama and dad. My mama and dad was taking care of my children, and that's the reason why I was out here working. I was sending money back home to see after my children. My baby, Sarah, she was only two. I would send money back there for my mother and them to keep them in school and keep them dressed. So I went back one year for Christmas to visit them. Then I came back here and went back to work at the Ramsey's.

I had my only experience with prejudice while I working for the Ramsey's. I'd been with them at that time for about 15 years. I went to work one day, and I saw one guy looking at me and following me after I'd gotten off the bus. This was over in Sausalito where they lived. I didn't pay him no mind. I said, "Good morning." He didn't say nothing. I went on to Mrs. Ramsey's, but after a while, the doorbell rang. It was a policeman and this man. The policeman asked her, "Has anyone been around your house, or do you have someone working for you?" I said, "Yes, I'm working here," and I looked right in the man's face. "I've been working here a long time." Then Mrs. Ramsey spoke to him. "You called the policeman? You better know what you're doing." He said, "I thought someone was coming to rob you." I said, "Did I look like somebody coming to rob when I was greeting you? I don't steal. I was taught to work for what I want, and if I want something, I work to get it." The policeman went to laughing and he said, "Sorry Mrs. Ramsey."

When I first came to Marin City in 1949, I didn't see too much of nothing but them little wartime houses. I said, "Shoot, this look like out in the country to me." Yes, it did. I thought I was going to see bright lights everywhere, but it looked like out in the country. My brother and his wife, before I'd gotten here, had told me about different things, the neighborhood and all that. But I'm a person who likes to makes myself known to people and then we'd go around together. Our next-door neighbor was in the Air Force, and he wouldn't be there all the time, and his wife did hair. I would go with her a lot of times. Then a lot of times some of her friends would say, "Come on, go to the store with me." So I learned about the area; at that time, Marin City was nice. It's nice now. We had a drugstore. This man—I can't recall his name—he and his wife owned it. We had a candy store. We had a beauty shop. We had a barbershop. We had two department, general stores. We had Wright Brothers, a big store, and then we had a small store, Slott's. At the Wright Brothers, you'd go in and

buy all your vegetables and meat and all of that. Then we had a dry goods store owned by a lady, and after she left, the Haydens took over. And we had a liquor store; Mr. Robinson was the head of that. We even had a little salvage shop, and people would get bargains there. You could walk to all the stores.

Then we had a ball diamond right out by where they had the flea market. We didn't have phones like we have now in the houses, but every corner had a phone booth. If it was raining, they kept the light on, a big light over the phone booth. We all shared them. Sometimes the phone would ring in the night, and it'd be for me, and some of my friends would go out there and answer the phone and say, "Nora Lee, you're wanted on the phone." Or I'd go out there and answer the phone and say to one of my friends, "Helen, the phone is for you." That's the way we did things until the people started putting phones in the house. But when I came to California, there were no phones in no houses.

When I first moved here, my brother and his wife took me over to San Francisco. Then I learned to go by myself, to catch the bus and travel by myself. I'd go to San Francisco, walk around, go into a restaurant, get me something to eat, and walk and look around some more. Then I'd catch the bus and come back home. I went to Macy's; I went to Emporium's and Lerner's. I also went to Kress' and Woolworth's because you could go in there and sit down and eat. I would always order me some fish if they had the right kind of fish. I'd order fish or eat some chicken. I liked perch. I liked blue gill and trout and stuff like that. Then I'd get me a salad. It wasn't that different for me as a black woman in San Francisco because back home in Granada we was almost doing the same thing. They was giving us privileges to sit where the whites sat. We would go to the movies, and we had to go upstairs and the whites downstairs. But they cut that out before I left Mississippi. We could sit where we wanted on the bus there, too. I never sat way back in the back of the bus because I ain't never liked it. I would sit halfway. They used to have that partition pulled down in church, and it was for blacks to sit in the back and whites up front. I'd sit there on the seat right closest to the partition—in the middle.

I lived with my brother and his wife until about '52. When I left there, me and my husband, George Condra, got married. I met him through a friend of mine. Me and her was at a party one night, and she told me she had somebody she wanted me to meet. She said, "Nora Lee, I want you to meet this man; he's a nice man." So I met him. He was working for a man that had cars over in Mill Valley. Then he left and went into construction work after the man made him a boss at the car place and asked him to move to San Jose, about an hour south of San Francisco. He didn't want to move, so he took another job. I didn't like him right away. I was just going out with him, I wasn't thinking about nobody at the time. I was just out here to work to take care of my children until they got big enough to take care of themselves. That's what I come out for. I had said I wasn't going to marry no more. Twice was enough. But he was so nice to me and my family. When it was time for school—I met him in the summer— he asked me did I have children, and I told him yes. So after I talked to him about my children, he said, "Tell me your children's names and how old they are." When it was time to go get school clothes, me and him went up to Albert's Department Store in San Rafael. We went up there, and he was picking out clothes for my children in Mississippi. At that time, you could have the store ship them back home. I shipped them back home, and George wrote on the packages, "if nothing didn't fit, send it right back." Everything fit because I was giving them clothes for two years older than what they wore.

He had been married once before, but he didn't have no children. His first wife died. She was also named Nora Lee. He didn't tell me until after he met me and me and him was going out. We went to a store to look at some shoes for me. I was supposed to go to a party, and I wanted a pair of shoes. I was trying on some shoes, and he went on and said, "Nora Lee, do you remember my other wife was named Nora Lee?" I said, "What?" "I like Nora Lees." I said, "You didn't tell me that, because if you'd have told me that . . . " I was just teasing with him. When we were dating, we used to go right across the bridge here to this place that had all kinds of seafood. We liked to go out, especially on Friday evenings. He'd come home and take his bath, get dressed, and come down and pick me up, and we'd go over there and eat. Then we'd go to the city. We'd go over there to some of his friends, or we'd go out to have dinner. Then we'd leave from there and take in a movie. Me and him would go to different theaters in San Francisco.

After we got married in 1953, we stayed in Marin City because he had an apartment, a duplex. When World War II was going on, he worked in the shipyard, and he lived at the dormitory over there in Sausalito. Then he got a two-bedroom unit, with someone living in back, which was at apartment 216; there were no streets yet. That's where his first wife and him was staying before she died. He and his other wife had it furnished up and looking nice, with two bedrooms and a living room, a dinette room, and a kitchen. After she died, he was renting out one of the rooms. But after we got married, he had me go back to Granada and get some of my children and bring them out here. Two of my kids lived with me when I first married him; I had five in all, and the rest were in Mississippi. With Mr. Condra, I had two more—seven in all. He told the boarder that he had to find another place. We stayed at 216 until they started building on the other side of Marin City. By 1960 I had all my children with me. We was still over at 216 because they hadn't gotten through with the townhouse that I'm living in now. We had the babies in the room with us. Then we had another room, and I had my boys in there. I had my two girls sleeping right on the couch in the living room. After a while, we got a bunk bed.

Before they tore down all the wartime houses and apartments, they showed us pictures of what Marin City would look like with the new homes. They had beautiful houses, so me and my husband put down $300. Then my friend, she put down $300. And another friend, she put down $300. Then we picked the spots that we would like to have for our houses. We put down the money and went to the next meeting. Then, at that meeting, they come with the houses on the poles. We have those in Granada, Mississippi, out there on the river in the swamps. Those people that live out of town, they come there and tie the boats to them big posts. When the water rises, the river runs over, and them boats come up to the top of the houses. Then they get in them boats and go on out. I didn't want a swamp house. It is embarrassing that the houses were built on telephone poles. Then you going to build a foundation in there and get the houses and set them down. "Aw, no," I told them. I didn't like that because I seen enough of that back at home. I got my money back. Some of my friends did move in them, but a lot of people redid them. But what's the use of buying a house if you got to fill in the foundation? That's what I don't understand. You pay the money for your house, and then you got to redo it. I thought about my daddy. My daddy bought some land and had his house built just like he wanted. But if you going to buy something, get something you don't have to do nothing extra to. Then you don't have to do nothing but move in. I didn't like the pole houses, but a lot of people did. I still don't like them, but if I had got one of

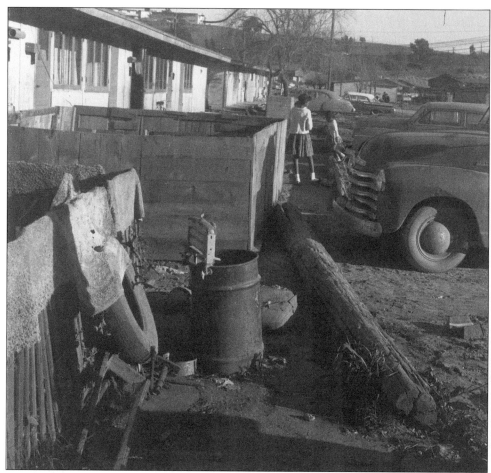

Wartime houses were built in Marin City for the workers at the nearby Marinship in Sausalito. (Photo courtesy of the Anne Thompson Kent California Room, Marin County Library.)

them, I would have redid mine, too. I'd have covered up them poles.

We had the best times of our lives together during Christmas. For my first Christmas in Marin City, I baked cakes and pies. People here was different from back at home, because for Christmastime in Granada, everybody would go around and taste some of your food and wine. My grandmother made homemade blackberry and muscadine wines and peach brandy. She'd have all the food set out, and she'd invite you to the table. Sometimes she'd be standing, take the cover off the table, and there was your long-stem glasses; there was this big pitcher of wine sitting there, and there's another pitcher sitting over there with brandy in it. Christmas in Granada was open house. You'd go to people's houses, and they'd come to your house. So that first Christmas at my brother's, I done baked up all this and set the table and covered it over like my grandmother. I could beat my sister-in-law's cooking. I'd been cooking and baking, and I fixed the cornbread dressing—everything. My brother came in the kitchen and said, "These folks ain't going to eat nothing. They looking for a drink." All the people done said was, "Don't you have something to drink? We don't want

nothing to eat. We want something to drink." I didn't know them that well, but my brother knew all of the people.

It was nice when we finally celebrated Christmas as a family after I married George, because I would cook, and my children, they love things like that. I would bake for Christmas morning. I also had a beautiful Christmas tree. Everybody got up Christmas morning, then washed their faces, put on their robes, and went under the Christmas tree. We had an old-fashioned record player that you wound up and then set the needle on the record. We played the song "I Saw Mama Kissing Santa Claus," and one of them would get to singing, "I saw Mama kissing Santa Claus up under mistletoe last night." Then we'd put on another record, for we had all the Christmas songs for my children. I told them, "Now you can't eat no sweets until you have you some breakfast." But we'd let them have apples and oranges and bananas.

We used to buy the Christmas trees down near here where the McDonald's is next to the filling station. Shoot, you'd get all the Christmas trees you want. I'd get the best tree for 50¢, and someone else done paid $6. I wait every year until Christmas Eve. That's when you can get them beautiful trees. At that time, they wasn't no more than $9. A woman who lived in back of me, my friend, she paid $6 for her tree. She said, "Nora, I sure got a pretty tree." So I went up there to the man, and he was fixing to burn the trees up. He said, "Go out there and pick out any one you want for 50¢." I said, "Me?" So me and my husband went down there and started at the bottom, just one layer, then come on up another layer, then come on up another layer, on up another layer until we got to the top. After I picked one out, I said, "George, Mary in the back of us got one look almost like mine. But mine looks the best." I got the tree and brought it home.

When we bought gifts for the children we'd go up to Woolworth's in San Rafael. We'd also go to the 10¢ store. I'd go to Montgomery Ward's in San Rafael; that's where I did my biggest shopping. Then I'd go over to San Francisco, if I wanted to get something nice for my children like sweaters and things like that, to Emporium or to Sears there on Geary. With Emporium I'd pay cash, but at Sears me and my husband had charge accounts with them.

We also went on family outings most Sundays after we came home from church. We'd come home, change clothes, eat, and get in the car and go up to Santa Rosa or over to Stinson Beach—all the beaches around here. My husband had some friends up in Sebastopol who had a little farm. He'd tell George, "Bring your children and we'll let them ride on the ponies." We'd go there, and they'd ride, and we'd buy eggs from guinea chickens. They also had duck eggs, and they had pheasants. We'd go up there once or twice a month, and one time I told my husband, "This area look like country. Just like back home in Mississippi." Then we'd also stop at this roadside stand and get bacon and eggs and buy hamburgers and fresh apple cider. We'd buy apples from the couple in Sebastopol, and I had to make some apple butter and give it to him and his wife. I'd make it for Thanksgiving. He also had us come up there and go out in his orchard and get walnuts. He had the black walnuts I like. I'd go out there, get some walnuts, knock the hull off them, then bring them home and crack them, and make the best walnut cake you ever tasted. It was like a fruitcake. I like fruitcakes, but I don't like to put candy in them. I put in raisins—and that's the only fruit—and I'll have pecans and black walnuts.

Another thing that gives me joy is quilting. I started with my mother. My mother was a seamstress, so she would make my dresses for me. She made my brother's shirts for church. We'd come home from school, and Mama would say to me, "You've

got to mend some socks." So I would go and do it real quick and then go out to play like any other child would do. I thought I had did a good job. My mother'd come and look at the socks while I was out there just playing. She said, "Lee, I showed you how to do the right stitches all tight and everything." She pulled the stitches out and said, "Do it again." I started out the first few stitches like she'd told me, and then I finished real quick again. When I went out I said, "I'm through Mom." She checked the mending and then called me in and made me do it over. I did the same thing, started out the right way and then got sloppy. She called me in again and said, "Now this is the third time. Do it again, and I'm going to spank you on your hand." I didn't want that. After I finished the last time, I didn't lay it down. She took it and looked at it. She said, "You did good, you can do it again." After I was finally done she said, "Now, go out there and play. When you get through playing, I want you to come back again, and I'm going to show you something else to do." That's how I learned. Then after that, my mother cut out something like a spider leg with a spider's body. Mama would light the lamps, and there'd be light all over the house, beautiful light. We would sit there and sew.

I didn't quilt none at first in California because I had to take care of the children. I started again in the seventies, when the flea market opened up down in the center of Marin City. I had my grandmother staying with me at the time. Some quilts was hanging out on the line that Saturday morning. I put them out to air; these quilts was made by me back in the South. So some people came over, and I guess they thought I was selling quilts. My grandmother was upstairs looking out the window at the flea market. She said, "Ooh, Lee, go out there. The people out there are at your quilt." I went out there, and they were feeling the quilt in their hands. I said, "Hold it, and take your hands off. Just don't touch them because your hands may not be clean." I called my husband to help me take them in. But one guy came up and said, "Are you selling quilts?" I said, "No, I'm not. They're just out for airing out." He said, "You makes quilts?" I said, "Yes I do. This one right here I made. And this one I made, and this one my grandmother made, and this one my mother made, and my grandmother made this one." He said, "Do you know the value of a quilt?" I said, "Yes, I do. Those quilts are not made by machine. Those are made by hand and all the top of it is cotton out of flour sacks." When I was younger you'd buy flour in sacks then. And you buy flour in the barrel. That's what my dad used to buy, a whole barrel of flour for Thanksgiving and Christmas, because he knew my mother would be cooking. "Yes, all of these quilts is out of flour sack. And the backs of them." I went on because my husband, I was giving him the quilts, and he was bringing them in the house. "The backs of them is flour sacks, also. My mother and my grandmother just bleached them. And right here is the cotton that came out of the field." He said, "I'll give you $5,000 for it." I said, "Naw." Then he went up to $10,000. I said, "Mister, you might as well stop talking." I wasn't going to take any amount of money. I just makes quilts because this is something I like to do. And I make them for my family, and there are some quilts over in the Oakland Museum as part of some exhibit. What I had over in the museum, those are older quilts. Those quilts are older than I am. I got a quilt that is 160 years old and was made by one of my great-aunts. Then I had one that my grandmother made, and I have one that I made.

The other part of my life that is very important to me is the church. I was in Marin City for, I guess, about four weeks before I went to church. I went to First Missionary, up on the right side of the firehouse and across from where the Senior Center is now. After me and George got married, I joined there. But I was trying to find a Holiness

Church because that's what we was raised up in. We finally found one. Me and my children would go over to San Francisco to Elder Taylor's church on Ellis Street. It was Pentecostal—the Powerhouse Church of God in Christ Pentecostal. So I joined there, too. In Marin City, Elder Pruitt had a Holiness Church, but they didn't have a church home. They'd just go to different places. After he left, Elder Bullitt finally got a place at the back of the school. The name today is the Cornerstone Church of God in Christ. In the Bible, Jesus says, "He gives us gifts when you receive Christ as your personal savior." He may give you a gift of going around and testifying to the people and prophesizing to them about the Lord Jesus. My gift is praying. I like to pray, and that's what God give me the gift of—praying for people. I can look at a person, and they don't even see me, and I look at them, and something just comes over me all of a sudden and says to pray for that person. It's just that the Lord reveals something within me. One morning I was listening at this woman singing over the radio, and something come over me so strong that said, "Just pray." And I got down on my knees and went to praying. Then I called my granddaughter in, and we went to praying. After she got through, she said, "Grandmother, what is it?" I said, "I don't know, but I felt like praying. I can't help it; when it comes over me, I say I have to pray." Just a few words and I'm through. I give it to God. It's in your hands. You do what you want to with it because we are in the world, and the world belongs to you, and everything that's in the world belongs to you.

My children know about Holiness. They were introduced to the Holiness Church before they was introduced to the Baptist Church, which is where we come from. But I introduced some of my children, even my granddaughter, over at Powerhouse Church of God in Christ. They was ushers. Some of them sang in the choir. I tell my children to get closer and closer to the Lord. Because if you get closer to the Lord and put your trust in him, can't nothing harm you. I think about Jesus dying on the cross and how the people was hurting him. He asked for water, and they filled that sponge up full of vinegar. Gave it to him and stuck it in his side—where he had an open wound. He groaned, but he said to his Father, "Forgive them for they know not what they do." That's what I try to teach my children today. Somebody misuse you. Somebody talk about you. All you got to do is put your trust in the Lord and say, "Lord forgive them. They know not what they do." We'd have a better world, and everybody would be of one accord if we followed that. But people are not like that. I try to do the things that's right. I don't try to harm nobody. I don't try to make fun of nobody. I tell my children that when I'm gone, that's it. They won't have nobody. They'll have to be there for each other.

Berenice Stohl often listens to the police scanner in her apartment when she isn't sampling food for the chef or baking cookies for "Tea and Talk." This photo was taken in September 1999. (Photo taken by Steven Friedman.)

CHAPTER FIVE
BERENICE STOHL

Berenice's mother once told Berenice that she never meant to conceive her, and her birth certificate proved it. Born on April 3, 1910, Berenice found out years later that her birth certificate only listed the date; there was no name and no indication if the new child was a boy or girl. Even though her mother was rigid and critical and this upbringing made her somewhat self-doubtful, Berenice didn't waste any time getting her identity revised. She was proud of herself and vowed to become a more supportive parent.

I got to know Berenice well in October of 1993. She was a member of the original group at my weekly life history sessions at Drake Terrace. She sat with Bea Rosenberg, and these two partners in crime would often provide caustic commentary when another resident shared his or her stories. I thought that they told great stories, but were pretty rude. It wasn't until Bea's death almost three months later that Berenice's persona softened—in my eyes. What I was able to see, and what had always been there was that she was sweet and possessed a droll wit. She poked fun at herself and others, and had little time for some of the self-indulgent narratives others revealed at "Tea and Talk." But down deep, she cares about people and cherishes her independence.

I've watched her now for more than six years, and I see how she relates to her family and friends. She positively adores her two daughters, Audrey and Linda, and two grandchildren. As a friend, she is loyal and a good listener. She is fairly easy-going and rarely holds a grudge unless she's been wronged. I think a lot of who she is was forged during World War II, when she was left alone to raise a newborn while her husband was in Europe for three years. Even though she lived with her mother, Berenice was ultimately responsible for her daughter's care. This responsibility finally earned her the respect of her mother and eased, as much as possible, the anxiety of her husband, the absentee parent during Audrey's early formative years.

The story of her courtship with Lieutenant Stohl, which you will read below, is legendary at Drake Terrace. I've made her repeat it at least a half a dozen times, for it reminds us of the unassailable bonds of romance. Not much could prevent her from sending Kenny a little bit of San Francisco while he was stationed overseas. One time she decided to send him some bourbon, but she couldn't figure out how to mail it so he'd actually get it. A friend suggested that she go to the bakery, buy some whole breads, and then pull out the insides and stuff the bottles in there. She failed to include a note explaining the gift, so Kenny wrote her a letter wondering if she'd lost her mind for sending him a package of stale bread. Another time he told her how much he loved onions, but because of wartime rationing, she could only get garlic. The produce man told her she could send and preserve the garlic if she

packed it in jars of olive oil. This time Kenny wondered why she was sending him bread that was all wrapped and tied up—until he peered inside.

There is another funny story from her past that is also somewhat amazing given the relationship Berenice had with her mother. When Audrey was about ten, she asked Berenice where babies came from. Berenice explained everything to her and then asked if Audrey had any questions. Audrey wanted to know when her parents were going to have sex again and could she watch? Kenny came in and asked them what they were talking about. Then he answered her, "Audrey, when I go to the pot, do I call everybody to watch? No, that's something private. It's between your mother and me, and we don't invite people in to watch." A few days later, the mother of Audrey's best friend called Berenice and wanted to know why she and Kenny were so selfish that they wouldn't let Audrey observe them as they had sex.

Berenice reluctantly went to Girl's High, on Geary and Scott Streets, all the while pining for the coeducational atmosphere of Lowell High School. (Photo courtesy of Berenice Stohl.)

Berenice and a classmate always
wore their best outfits when attending
Rochambeau Grammar School, which
was a block away from her home on
24th Avenue in San Francisco. (Photo
courtesy of Berenice Stohl.)

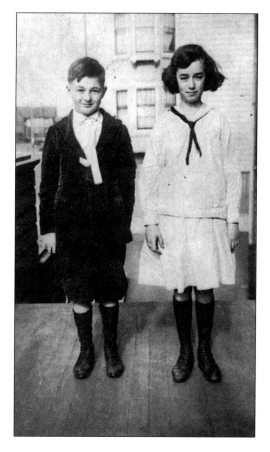

My folks moved back to San Francisco in 1912, when I was two years old. They'd been in Benicia, where my father was secretary of a tannery, since the 1906 San Francisco earthquake and fire. My father was an attorney, and he passed the bar, but I don't know why he didn't practice law. When my family returned to the city, he and my uncle went into the leather goods business. The two of them did that until my dad died in the early 1930s. My father and his father were born in England, and his mother came over from Poland when she was 16; their marriage was an arranged one. My grandparents had four children and came to America in steerage class and landed in San Francisco. They first lived on Minna Street, which is south of Market Street. They were religious Jews, but I don't remember much about them. About all I can remember is that my grandfather was a big man with a red face; he died when I was quite young. My mother's parents came from Exene, Germany, but I don't know when. She was born in San Francisco and lived near my father and his family, so that's how they met.

My father was a great man who lived for his three children. We loved each other a lot, and we were very, very close. Whatever I said to him was right. He was about 5 foot, 8 inches tall, not too heavy, and he wore glasses. Whenever he had his picture taken, he would always dress to a "t." I loved my mother because she was my mother, but sometimes I didn't like the way she treated me. According to her, I could never do anything right. When I'd shop for a dress and return home, she'd say, "Oh, why do you like that?" She was very hard on me. But to my brothers she was wonderful. I had two older brothers, Jimmy, who was five years older, and Monroe, who was nine years older. Monroe became a dentist. Anyway, she adored them, especially Jimmy. One time I heard her say that he was more a daughter to her than I was. Another time she told me that getting pregnant with me was a mistake. It wasn't until I was married and my two daughters were older that she said to them, "I hope you are as good to your mother as she was to me."

She'd grown up the same way she'd treated me. Her father was very stern, and she was the same with me. One time a cousin, a boy my age, and I were downstairs—I don't think we were doing anything bad—but my mother came and dragged me upstairs and said she's going to call the detention home. I guess she thought we were playing house. But I don't remember doing anything like that. And I thought, Why is she calling the detention home? So she pretended that they had come and were going to take me because I was a bad girl. She didn't tell me why I was a bad girl; she said nothing, but her look said everything.

She said very little to me about anything. Not about menstruating or anything; my girlfriend told me. We'd see women with big fat stomachs, but we didn't quite know how their stomachs got so fat. One night, my brother was home, and I got my period, and I thought I was dying. I thought I was hemorrhaging. I remembered walking along Market Street with mother to take the ferryboat to San Rafael to visit a relative. She told me that some day I'm going to have a "sick time." But she didn't tell me what she meant by a sick time. So when my period finally came, I went to bed and said, "Oh, I'm dying." The next morning, I didn't want to get out of bed, but I didn't tell my mother why. When I got out of bed, she saw why. This was my sick time. During my sick time, I couldn't take a bath, wash my hair, or have anything with vinegar in it. She'd always put up pickles, and I'd sour them. But God forbid I should get near anything pickled. They didn't have Kotex in those days. They had something like diapers, big square pieces of material that you folded up and made them long; they had belts that you'd pin them on. Terrible. Everybody in the neighborhood

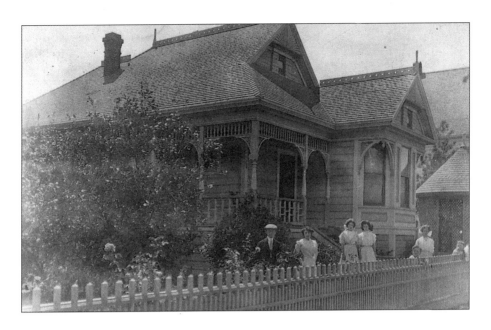

Though she lived almost her entire pre-married life in San Francisco, Berenice was born in Benecia, which is 45 minutes east of the city, and lived in this home until 1912. (Photo courtesy of Berenice Stohl.)

knew when anyone had their period because there'd be all these white things out on the clothesline. You washed them after you'd dump them in a bucket full of Clorox. Oh, it was messy. Kotex was the best invention that ever happened; then Tampax. When this happened to my daughters, I told them that it was a very normal thing. You can take a bath, and you can have dinner; you can do everything.

I remember other ways we had to treat sicknesses. During the flu epidemic of 1919, we wore something around our necks, camphor with gauze. We were also supposed to wear a mask. One policeman that lived on our block went around looking to see if any of the kids were without masks. He had a bag full of them, and they were supposed to keep us from the flu. Also, every time I had a cold, my father would come in with this eucalyptus oil and sprinkle it all over my pillow. Oh, I hated that. If we had a cough or something, he'd put a mustard plaster on us. It burned. Another time, when I was six or seven, I had my tonsils out. The night before, there was a party for all the kids at my aunt's apartment. The lights were off, and all us kids had a race to drink a glass of root beer. Whoever drank fastest would get the prize— a dime. Well, I noticed in my root beer that there was a dime on the bottom. In those days, you had to take castor oil before you had surgery. It didn't taste very good, but at least I swallowed all the root beer. The party and race were for me to take the castor oil. After we drank all the root beer, the party was over. The next day, I went to the hospital on California Street near Jordan Avenue. I don't remember much about the surgery. I stayed overnight, and they gave me ice cream, and I didn't have a sore throat. My mother was mad because they brought me toast to eat for breakfast, and she didn't think that was a good thing for me to eat after my operation.

Our first home in San Francisco was on Presidio Avenue. It was an apartment building about three stories high, and we lived on the third floor. The iceman and

the garbage man had to come up three flights of stairs. They came early in the morning, and you could hear them clanging up the stairs. I also remember that we had to put slugs or nickels into the telephone. Then the telephone man would come to collect. We used a Chinese laundry that charged $1.25 a week. My father and brothers always wore white shirts, so there were 21 shirts every week. They also mended things and sewed on buttons. We had a scrubbing board for some of the laundry. We'd do it and then hang it on the line.

We always had hired help. In those days they used to get these girls fresh over from Ireland who would live with the family in the house. They were usually Irish girls because they were the ones that wanted to come over to the States. We never had many blacks in San Francisco until World War II when they came out to work in the shipyards; it was mostly the Irish who were the domestics. They'd have room and board for $15 a month. I guess I made my bed, but that was about all I did around the house. My mother always cooked, but I didn't have to help her. The hired help did the dishes, the housework, and all that stuff.

I never helped mother cook because when I'd get in the kitchen, she'd always say I was doing everything wrong. Even after I got married, she couldn't understand why I had to have a recipe. You'd ask her for a recipe, and she just said, "A handful of this, a handful of that." The only time I cooked was if she and my father went away for a few days. Then I always made corned beef. I knew how to prepare corned beef—cook and then bake it. One time they went away, and I was cooking something with French fried potatoes, and the oil caught fire. I was stupid. I didn't know, so I put it in the sink, put water in it, and burned the curtains. But the Irish maid and I didn't have to call the fire department. We put it out. When my folks came home I said, "You better be thankful that that maid and I are alive, and I didn't burn the house down." The kitchen was all black with soot. But it was okay; it was close to Thanksgiving and right before they planned to have the house painted.

My mother was a very good cook—until she got older. She used a lot of garlic, which all of us liked. One thing I didn't like was when I'd walk in the house and smell something fishy. That meant my mother was making gefilte fish, and every time she'd have fish around, I couldn't stand the smell, and I didn't eat it. I'd say, " Ughh!" She bought whole carp and whitefish. She took pieces of them and put them through the hand-grinder. Then she made balls out of the mixture and cooked it, boiled it. And then she served it with horseradish. Of course I wouldn't eat it then, but I love it now.

From Presidio Avenue, we moved to 24th Avenue. I went to Rochambeau Grammar School, which was a block away. We spent a lot of time outdoors, where we played tag and a lot of ball. Just past 28th Avenue were all sand dunes that were close to China Beach. It's still there, but now you've got to go through the Sea Cliff neighborhood to get there. Back then we had just a little path that we slid down near the regular little cove. We'd go there all the time to wade in the water when the weather was nice; we wouldn't go out in the surf. We used to go out there and light bonfires, cook hot dogs, and bake potatoes. Sometimes we went to one of the neighborhood stores, Kennedy's, on Clement between 24th and 25th Avenues. If we had enough money, we bought a box of Flicks. They were just chocolate pieces in a tube. Or we got the little chewy peppermints, like tiny cushions, with brown and white stripes. And Kennedy's had a circulating library in the store as well. When I was older and off penny candies, I read a couple of books a week. If I found a book I liked, I wouldn't put it down until I finished it.

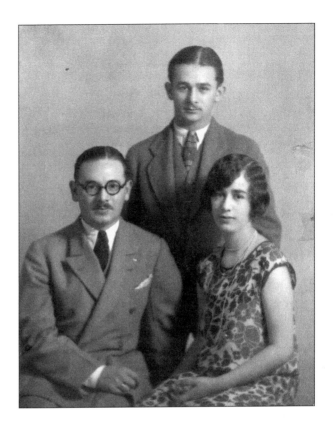

Berenice was close with both her brothers, Jimmy (standing) and Monroe. Shortly after she left the University of California at Berkeley, she began working as an assistant in Monroe's dental office. This picture was taken when she was 19 in 1929. (Photo courtesy of Berenice Stohl.)

I also liked shopping and going to the movies. I liked going to the White House Department Store, which was near Stockton and Grant Streets. There was the Emporium and Hale's on Market Street. I went to the Star Theater on 25th Avenue and Clement Street. We used to get in for a nickel for several hours worth. They always had somebody playing the organ or piano or something. Then you had your news from around the world, and then the one movie, several hours worth every Saturday. There was always a serial, *The Perils of Pauline*. It would be a train and somebody jumping from one car to the other, and then it stopped. You had to go back the next week to see the rest of it. Sometimes on weekends, they gave away glasses or dishes. When I was older, we used to like to go down to Blum's on Polk Street to get hot fudge sundaes.

We also went to Playland, which was out by Ocean Beach near Balboa Street just below the Cliffhouse. We usually went on Saturdays. There was the Big Dipper and a roller coaster. That was the first time I ever ate an "It's-It" bar. An "It's-It," which started in San Francisco, is two oatmeal cookies with ice cream in between, dipped in chocolate. Then we'd eat hot dogs or enchiladas. When I was 13 or 14, my girlfriends and I would take the Geary streetcar all the way out to Sutro Baths on weekends and walk down along the cliffs and trails. At Sutro Baths, you had to go down a lot of steps. They had a lot of swimming pools there, a great big pool that was at regular temperature, an icy, cold one, and a hot one. I didn't have a good stroke, and I never really took swimming lessons.

Our family went on a lot of outings. The first one was in 1915, when I was five. We went to the World's Fair [Panama Pacific International Exposition] in San Francisco,

which was down in the marina where all that filled land was. All I remember is going with my mother and father to a place enclosed in glass where doctors examined me. I stood on something while I was completely nude, and all the people were passing by. Why in hell did they do that to a little kid? I was very skinny, so maybe my mother was worried.

We used to have a lot of family picnics during the summer. We'd go to Sears Lake, which was south an hour or so. The whole family would go down there, and one of my uncles would do all the barbecuing; we'd do that practically every nice weekend on Sundays. During the summers, we went to Summer Home Farm, which was up in Sonoma County, for two weeks at a time. We used to walk across the field to a swimming pool because the river was dammed, and that's where I eventually learned how to swim. My brothers threw me in, and I had to get myself out. I did the dogpaddle. We also went to Boyes Hot Springs, up in Sonoma, for a couple of weeks in the summertime. A big thing to do there was to walk down to the station and watch the train come. The whole family would go to the station. Since this was before the Golden Gate Bridge was built, we had to take a ferryboat from Hyde Street over to Marin County, then drive or take a train, but we always drove, because we'd have so many suitcases.

We also stayed indoors to entertain ourselves. We'd play card games, like casino, or we'd talk because we didn't have radio or television then. My brother made our first radio out of an oatmeal box. It was a crystal set, and you had to have earphones. The first time that radio came on, I think it was Mayor James Rolf of San Francisco. We all huddled outside and took turns with the earphones to hear him speak. Then they got the radios in, and our first one was an Atwater Kent. Sunday was a big radio night. They had the serial drama, *One Man's Family*, and that was from San Francisco about a family that lived in the Sea Cliff neighborhood. They had *Burns and Allen, Fred Allen and Jack Benny*, and *Amos 'n Andy*.

My oldest brother Monroe taught me to drive in the family's Packard sedan. One night he got home from work at about five-thirty. He said, "Come on, sis, get in the car. We're going to go take a ride." Then I drove down Geary Street in the Richmond District, and there was a lot of traffic there. Finally he said, "Pull over and park." I did, and then he got out of the car, so I said, "Where are you going?" He said, "I'm going to take the bus home and you're going to drive the car home alone." And I said, "I can't." And he said, "Oh, yes, you can." So he left. And I did it. By the time I got home, I had confidence. I kept driving, but I didn't get a license until I was 40.

When I was a teenager, we moved to 29th Avenue between Clement and California Streets to a house with a postage stamp garden in its tiny yard. I went to Girl's High, which was located on Geary and Scott Streets. I was on the crew team, though I wasn't much of an athlete. One time we were rowing in the marina, and we got stuck in the mud. We had to get out and wade across. There were maybe eight of us, but we didn't do very well. We never competed against other schools. Another time I went out for basketball, but they kicked me off because I was fouling everybody. I hated Girl's High because there were no boys. I wanted to go to Lowell because both my brothers had gone there. But I had two cousins who went to Girl's High, though they had already graduated, so I was sent there. I don't think I went on any dates during my four years of high school. Every Wednesday in the recreation area there was a dance. So girls danced with girls. There was one girl, Veda Sentencet, and I had this crush on her. Everybody had a crush on her; she was the yell leader at pep rallies and a senior. I started dressing like her—heavy, bulky roughneck sweaters, no

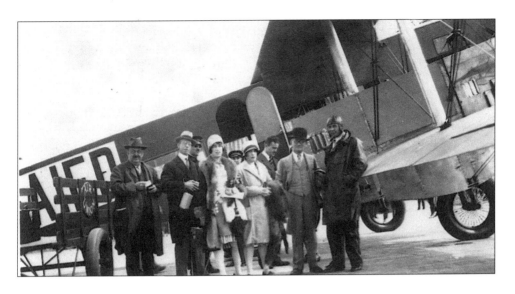

Berenice's parents took her to Europe one week before her freshman finals at Cal in 1928. She never returned to college. Before the family landed in France, the turbulent ride caused several passengers to get quite sick. Her mother, who was not especially religious, recited Judaism's most hallowed prayer, the Shema, the declaration of God's oneness. (Photo courtesy of Berenice Stohl.)

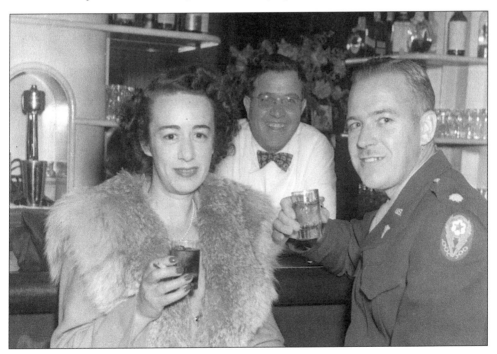

Because it was forbidden for civilians and officers to fraternize, and because Berenice feared telling her mother that Lieutenant-Colonel Kenneth Stohl was not Jewish, the couple, employed together at the Presidio Medical Depot, courted and married in secret. (Photo courtesy of Berenice Stohl.)

lipstick or powder. One time I was practicing French over at a classmate's, and I had all these photographs of Veda. I didn't know about gay people, and I had no romantic designs on Veda. Well, this classmate's father went to my father's office and told him about the pictures. I was just following what everyone else in school was doing by emulating Veda.

I did have fun during high school. I enjoyed being part of the Camp Fire Girls. You could become a Fire Maker, Wood Gatherer, or something else. You had to make your own costume, like a uniform. It was supposed to be long and fringed, and with my father being in the leather goods business, I could have a leather fringe. It was easy to make because my mother had a sewing machine. I was supposed to look like an Indian maiden. We did ceremonial things, Indian-style, and you went from one rank to another. I even went to Camp Fire Girls Camp in the Santa Cruz Mountains. We had four girls to a tent, and there was a pond and a pool. They had showers, which were hoses coming in with cold water. I remember my parents came to visit me after I'd been away for two weeks, and my mother took me to the showers and just scrubbed me; it was pretty dirty at the camp.

On weekends in our neighborhood, four or five of us had luncheon parties, where you'd play silly games when someone had a birthday. One of the games was where someone would bring a tray out with a lot of stuff on it and then take it away, but you had to remember how much was on it. Those parties were for girls. Then some of the girls would have parties at their homes on Friday nights. Ruth Elkins's brother brought these fellows home every Friday night, but she stopped inviting me. She had over my other friends, Marie and Mary, but she told one of the girls that she didn't have me because I'd flirt with the boys, and they wouldn't like it. That was funny because I was truly scared to death of the boys.

I really didn't have any boyfriends until after high school. After Girl's High, I went to the University of California at Berkeley for a year. I left before my final exams because my parents took me on a trip to Europe in 1928. I never went back, though I'd planned to. Anyway, there was one boy I'd met in high school, when I was about 16, and his name was Gerald Karsky. Our families used to vacation together in Yosemite. One time he and I ate all of his father's apricots, and his father was so mad that they went home that day. His father owned the Grand Lake Theater in Oakland, and Gerald had given me a lifetime free pass. When I tried to use it the first time, they asked for it back, maybe because we had eaten all the apricots. I had boyfriends when I was 18 and 19 and in my 20s, but I was only really serious with one of them before I met Kenneth Stohl.

After I returned from Europe, I worked as a dental assistant for my brother for nine years. In 1938 I got a job as a civilian in the medical supply depot at the Presidio, which was run until recently by the Army. I worked in a warehouse, taking care of the requisitions. It was a big, long warehouse with a front office just as you came in. Right down at the end of that was an office where I was, pulling supplies off the shelves and putting them in one area for the warehousemen to pack the items and then send them off. One time they brought in some field chests that'd been stored since World War I. We were going to see what we could save and what we would have to throw out. I had to match up everything to a catalog. I came across these pills that said 'heroin' on them, and I'd never heard of heroin in my life. They weren't listed in the catalogue, so I took them to the Colonel. He grabbed them, and together we washed them down the sink. Later on, they brought me out of the basement, as I called it, and into the front office. I was in purchasing and ordering

supplies. They had me there because I had done some keypunching part-time for the city of San Francisco during tax season. I was in that place for about a month and a half until I went and complained. You didn't need any sense to punch numbers and all. Didn't have to use your brain, so the Colonel put me on purchasing.

One of the things we were always told was that civilians could not fraternize with any officers or enlisted men. It was 1940, and I was in purchasing, when two new reserve officers, Lieutenants Bowe and Stohl, came to the depot. I said to Ruby, the other single girl there, "I'm taking Stohl and you can have Bowe." Didn't know anything about him. The first time I met him, a group of us were sitting outside the warehouse. A Nash coupe drives up, and there was Stohl in his uniform, and he had a gold cap on one of his teeth; it looked terrible. Well, even though we couldn't fraternize with officers and enlisted men, a bunch of us always went out for drinks at this bar on Fillmore Street between Lombard and Chestnut Streets. It was called Rollins or Cervasi's, and we'd drink and then dance to the jukebox music. Even the captain who said we couldn't fraternize was there.

For a couple of months, a group of us always did that, and then Kenny and I started having dinner out alone after the drinks and dancing. He was the officer in charge, and I worked under him. After some time, he and I started dating. We went tea dancing at the Palace Hotel, where they also served hot drinks and chocolate from four to five in the afternoon. We went to the St. Francis Hotel a lot for dinner and dancing to the Lofner Harris Big Band. Sometimes we went to the Legion of Honor or Land's End for a little petting and lots of kissing. There were a lot of cars there and plenty of steam going. One time he called me—we were working in different offices—and said, "Meet me in ten minutes. We need to go under the Golden Gate Bridge to survey the x-ray machines," which were located in storage near Fort Baker. We inspected the machines, but then he kissed me, and we made out all through lunch.

My mother knew I was dating Kenny, but I couldn't tell her how serious we were because he wasn't Jewish. I used to tell her I was going out to dinner with friends or spending time with Genevieve, who was Kenny's sister and roommate. One time he proposed to me at that bar on Fillmore Street. He said, "What do you think of getting married?" I said, "Getting married? To whom?" He said, "Well, who do you think?" I said, "It sounds pretty good, but let's wait awhile." I didn't want to tell him that I'd have trouble with my mother. Another time, in July of 1941, he said, "I'd like to elope. Let's elope. Then we won't have to have a fancy wedding. If we have a big wedding, I'll have to tell the Colonel,"—who also didn't know about our romance. So, we got married on August 17, 1941, but I didn't tell my family. We went to Las Vegas; we thought about Reno, but I had a cousin there, and she read about all the marriage licenses in the newspaper. For $150, United Airlines arranged everything. He borrowed the money from me because he was broke. We flew on one of those propeller things, no jets in those days. Two United people met us at the plane and then took us to the courthouse. We got our license. Then the doors opened, and they called out, "You're next, you're next." The judge performed a quick ceremony and then said to Kenny, "OK, you may kiss the bride." That was it. Then we went down to the bar for a couple of drinks, paid for by United, and then we left to return to San Francisco. His sister took an apartment with some girls, and he got an apartment across the street from where I lived with my mother. So that made it very easy. He had arranged that before we were married. My mother and I lived on Divisadero and Bay, and he was on Bay and Divisadero. And the entrance to my mother's apartment

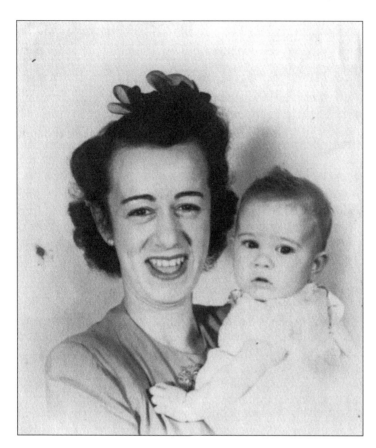

Berenice gave birth to her first daughter, Audrey, while Kenny was overseas in Europe during World War II. He did not meet his daughter until she was three. (Photo courtesy of Berenice Stohl.)

was on Divisadero, and the entrance to his was on Bay Street. She never saw me go in or out. Of course, I was supposed to be staying with his sister.

So Kenny and I lived and worked together after our marriage. I remember we had blackout curtains because of the air raid warnings. Each block had a warden, someone to walk around and see if any lights were on. This was right after Pearl Harbor. If your curtains or your shades didn't fit tightly, then you had to have a piece of black paper or material so no light would shine through. The weirdest thing was that those of us at the depot had to take turns staying in the warehouses all night—with someone in each one. Kenny was in one warehouse, and I was at another, and I don't know how come they let me be in this goddamn big warehouse alone, all night long. Every hour on the hour, someone was supposed to call me, and if I didn't hear from that person, I'd call. If he didn't answer, then I'd call the police. One night, right after Pearl Harbor, I was alone in that empty front office. And it was cold. But everybody reported in on time, so we found out we had no problem.

Anyway, since Kenny and I were both 31 when we got married, we didn't want to wait to start a family. Evidently, I got pregnant right away but didn't know it until I was in my fourth month; I was very irregular anyway. Maybe twice a week, I spent the night at his sister's—so my mother thought. So in late December of 1941, after we'd been married for nearly five months and I was pregnant for five months, Genevieve called my mother and said she hadn't seen me in awhile. My mother was surprised because she thought I'd been staying with Genevieve. That was when my family

found out. My mother was mad I hadn't told her; she would have wanted to have a little reception for us to tell everyone. After Kenny finally told the Colonel about us, the Colonel called me into his office and said, "We can't have a husband and wife team working in the same office. I can get you a position at Fort Mason," which was near the marina. I told him no, though I couldn't say I was pregnant, and that I was going to quit. So I quit that day.

Audrey was four weeks old when Kenny was shipped overseas. He was part of the first landing of Americans in Europe, near Liverpool. I moved in with my mother at her two-bedroom apartment on Euclid Street near Jordan Avenue. It was very bright and cheerful, and there was a courtyard in the back. It had a fire escape, and we had the two bedrooms in the front of the house on Euclid Avenue. There was a dining room, a living room, a nice big kitchen, and a hallway where the third bed, which was really the maid's room, and a toilet with a wash basin. I paid half the rent, which was maybe $200 a month. Kenny didn't return until August 1945, soon after VJ Day. After he came back, he was stationed at Dibble General Hospital in Menlo Park, 35 minutes south of San Francisco, in the medical supply unit. At first we couldn't find a place to live down there, so I was still with my mother. Eventually we found a basement apartment in an old house that'd been converted to three apartments. One year later, he was transferred to Letterman Hospital in San Francisco. We rented a house from my brother and sister-in-law in St. Francis Wood on San Benito Way. We paid what mortgage they had to pay off. It was a cute, little house, up high from the street. It had three bedrooms and one bath, with stairs going up in front, a patio in front, and a garage. But the house had a lot of dry rot, so we decided to fix it before the birth of my second daughter, Linda. One time I got home, and the bathroom wall was down; there was canvas over it. I'd go to the bathroom, and the workmen would talk to me through the curtain. But it turned out to be a nice little house.

Years later, after we'd retired in the 1960s, we were with our RV and some other couples, and we got to talking about different things. It happened we were talking about how we ran away and got married. And I said, "You know, he borrowed $150 from me, and he hasn't paid me back yet." A couple of weeks later, it was our anniversary, and we had a dinner on a Saturday night where everybody brought something. We were at a campsite with other retirees, and he had this envelope that he gave to me and said, "I'm tired of hearing my wife tell everybody that she had to pay for our wedding. So here's a check for it." He gave me $150. I said, "You couldn't pay interest, could you?" We both thought that was funny.

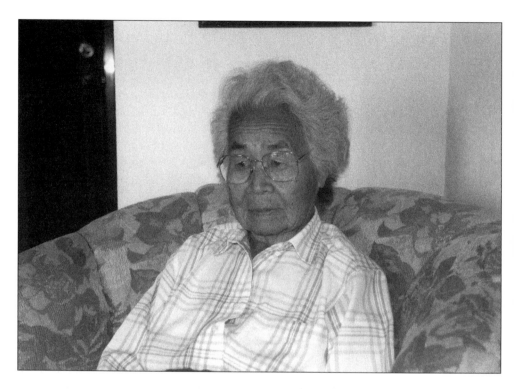

Mutsu Muneno, who endured the humiliation and hardship of internment of the Japanese and Japanese Americans, spends her days beautifying the grounds at her retirement facility, reading, caring for her dog, and being with family. This photo was taken in September 1999. (Photo taken by Steven Friedman.)

CHAPTER SIX
MUTSU MUNENO

If the weather is good, you will find Mutsu in the garden everyday. Since coming five years ago to The Redwoods, a retirement facility in Mill Valley, she has single-handedly transformed the once barren grounds into a dazzling array of flowers, plants, and shrubbery. This spry 91 year old, who is thin and under 5 feet tall, considers it an honor to be the resident green thumb. "When I moved here, I wanted the old ladies to get color. All the flowers and plants brighten their days." Her favorite location, among the five spots she tends on a regular basis, is the Potting Patch, a mound of gorgeous flowers surrounded by discarded potted plants that Mutsu has nursed back to life. "Whatever plants people do not want in their apartments," she explained, "they give to me. I guess the people get impatient in their old age. I tell the plants, 'Now you grow; I'm giving you a second chance.' " As we toured the Patch, ringed by red dahlias, blue lobelias, orange and yellow nasturtium, light blue and purple chrysanthemums, white petunias, and other varieties, Mutsu said, "This is my helter-skelter garden; there's no rhyme or reason."

Through the gentle and earnest way she cares for the gardens and carries herself each day, Mutsu shows that her life is filled with rhyme and reason. Like her father, she has a poet's soul; there's a cadenced quality to her speech and movement. She also learned from a very young age the practical value of education and of bettering oneself. Her parents, especially, and teachers played a pivotal role in developing her philosophy of life and attitude toward others. "My father used to say, 'Go to school and educate yourself, and you will be respected.' Both my parents showed me through their own behavior to be kind to our neighbors and help them whenever they needed it." She is considerate, insightful, and has a sharp sense of humor. During our interviews, she did not hesitate to make fun of herself or to lavish praise on her family and friends.

But she has also known hardship. She had to endure the forced evacuation and relocation of her family in 1942, when over 120,000 Japanese Americans from the West Coast, two-thirds of them U.S. citizens, were sent to concentration camps. She and her family, along with her sisters' families, were sent first to Tanforan Racetrack, 15 minutes south of San Francisco and one of sixteen assembly centers that temporarily housed people before they were removed from the West Coast. She was married with three children, but her husband was sent, after a short time in the permanent camp, to teach Japanese to the GIs in Ann Arbor, Michigan. The family's permanent site was Topaz, Utah, one of ten concentration camps replete with barbed wire and armed guards. There were also at least a half-dozen other camps for citizens and non-citizens labeled as troublemakers by the War Relocation Authority, established by President Roosevelt in March 1942 to administer the camps. Her and her family's experiences at Tanforan and Topaz represent a tragic

and sad chapter in American history.

After all she's been through, though, Mutsu sometimes feels that her life has been very ordinary. What is not ordinary are two images—of Mutsu caring so gracefully for the greenery at The Redwoods and of her suffering through the pain and humiliation of internment—that are incongruous but reveal her extraordinary life. One is peaceful and meditative; the other is stark and raw. But both highlight the indomitable spirit of someone who embraces the power of living. She labored mightily to provide her interned family with as much comfort as possible with the same determination that she's used to rescue unwanted geraniums. I don't think it's a coincidence that a wind chime hangs in the Potting Patch, whispering its cling-cling to everyone who passes by. It is a lyrical reminder of the presence of the moral life force that Mutsu has cultivated in her little corner of the world.

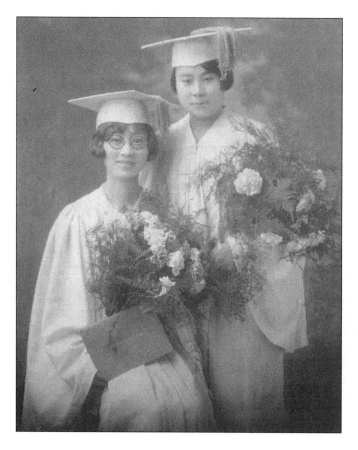

Mrs. Muneno (right) and her best friend, Mary, share the joy and relief of graduating from grammar school near Sacramento in 1922. (Photo courtesy of Mutsu Muneno.)

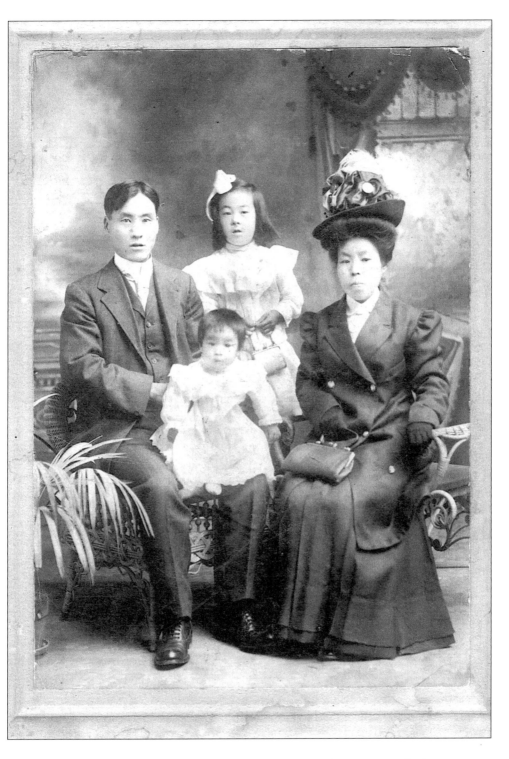

Mrs. Muneno and her older sister, Cheiko, are pictured in 1908 with their parents when Mutsu was six months old. (Photo courtesy of Mutsu Muneno.)

I was born in apple country, north of Petaluma in Santa Rosa, which is about an hour from where I live now. My parents had a friend who worked there, and he said, "Come here, and you can work on the apple farms." My parents were immigrants from Japan, and my father had never done manual labor before he came to the United States. He was very philosophical and a sort of idealistic person who was rather tall for a Japanese, and he had a great deal of foresight, was good with people, and everybody respected him. Many of the immigrants were young men with not much education in those days, and if they had marital or financial problems, they would consult my dad. My parents were good role models for a healthy marriage because he and my mother rarely argued throughout their lives together, and she never contradicted him. If they had an argument, they would talk about it very quietly—even if we were around. They wanted to instill in us that you could give your opinion, but you should also listen to people. And you shouldn't let anger get the best of you and start an argument just because somebody didn't agree with you. He was a schoolteacher in Japan, and that really impressed these men, and he was good at writing haiku, seventeen syllable poems. Whenever the Japanese immigrants had a meeting or a dance or anything like New Year's, a group of men would go from one place to the other. They scattered all over but would stay within a radius of 3 miles or so. At each place, they would have sake [rice wine] and clap and sing, and then my father, who could not carry a tune to save his life, always said, "I would like to be excused from singing but if you get me a pencil, I will write you a little haiku towards this occasion." That's the way he got out of it.

My parents first came to Hawaii and worked in the fields. But money was scarce, and more children started coming, so my father decided it was better for us to move to California where he knew a few people. My father was a firm believer in education, and unlike a lot of farmers in Hawaii who put their children to work, he said, "No, all my children are going to school, so people won't say he or she is a baka." Baka means fool in Japanese. He wanted us to be respected not only for our education, but for the learned things we said. He said, "You might not get rich with an education, but you will be respected." My parents left Santa Rosa and moved to San Mateo, about 20 minutes south of San Francisco, when I was about six. They went to work in the Leslie Salt Mine. My father worked in the mine, while my mother and the other women cooked for a group of men that worked there. Every time I passed the mine, I could see all the salt: huge piles of white salt inside, not on the beach, but a little further in closer to the buildings. I was very young, so I don't remember much from Santa Rosa or San Mateo, except what my mother used to say. She said, "Don't ever forget what you owe your older sister, Cheiko. When your dad and I were working, she used to take care of you. She even did your wash for you. So don't forget that."

A little while after my father started working at the Leslie Salt Mine, he decided to rent a farm. He rented a place just outside of Sacramento in Riverside. Nowadays, Riverside would be 15 minutes away from Sacramento by car, but in those days, the horse and buggy took a long time. We had a big old house on the farm with spare rooms, so the local Methodist Church asked if they could have a church service there for the children. They used it for an orphanage and a Sunday school, too. That way, we met a lot of children when we first moved there. We had some wild times running around and doing things. In our yard, there were wildflowers, lupines, and poppies that we picked when we wanted to take bunches of them home. The area had a levy and a canal going through it. There was Riverside Park, and nearby was a private

The Moon Bridge, which casts its semicircular reflection in the pool below making a full circle, is part of the Japanese Tea Garden in the Golden Gate Park. The tea garden was built for the California Midwinter International Exposition of 1894 and is one of only two structures that were not taken down at the fair's end. The tea garden is still known as an architecturally beautiful treasure of footpaths, bridges, flowers, trees, pools, shrines, gates, and statuary. The Hagiwara family cared for the tea garden from 1895 until World War II, when they and 120,000 other Japanese Americans were forced into internment camps away from the West Coast. This photo was taken in the 1930s. (Courtesy of The Anne Thompson Kent California Room, Marin County Library.)

Tanforan Racetrack in South San Francisco was a temporary home to thousands of Bay Area residents before they were evacuated to permanent sites away from the West Coast. People lived in prefabricated barracks and in horse stables with sewage running outside their doors. (Courtesy of the National Japanese-American Historical Society.)

swimming pool we also got to know well.

We had a big family. There were five girls and two boys in California. We were close to each other because we grew up in a calm sort of an atmosphere, and if we had something to say, my parents listened. But when we fought, my mother would sigh, "I know you're children, so if you want to fight, go ahead. But don't ever go out of this house and fight with other children or other people."

One of my brothers was left behind in Japan as a security. Since the records showed that they were the 17th generation in Japan, many of the relatives didn't want my father and his family going to a strange country. The relatives thought they'd never see them again. My father said, "One day we'll come back if we get enough money." They said, "If you leave your son here, we'll know you're coming back. That will be the guarantee." With that understanding, they said he could go. My parents left him when he was four with my grandparents with the promise that they'd return in a year or two. But money was hard to get in those days, the early part of the 20th century, and they never saw my brother again. My father was getting ready to return to Japan when World War II broke out. My eldest brother was 60 years old before he came to see us in the United States. My sister remembers how all of us, who were married and with families of our own, pooled our money to bring my brother and sister-in-law to the United States. He'd been a teacher and was recruited into the Japanese Army. I first met him in Japan after the war because my husband went to

teach there. Although I had never seen him before, he looked just like my dad. He was tall and walked like him. When he and his wife served refreshments, tea and some Japanese cookies, the words blood is thicker than water came to my mind. His expression, and the way he reached for his cup or cookie, was that gentle way of my father. I was quite intrigued watching his hand movements. He never grabbed things; he just slowly reached up and said thank you and took it to himself, exactly like my father. So I felt real close to him as soon as I saw him.

I was a tomboy, and my brother and I were just like a pair of monkeys. I was always interested in sports, mainly baseball and soccer, but later I loved golf and tennis. I started golfing when I was 18. My brother and I went to the new golf club across the street. I hadn't taken any personal lessons, but if you're athletically inclined, the form comes naturally. Or we'd play hide and seek in these big, resilient elm trees outside our house. I'd chase my brother, and he'd go down on the limb, grab something, and slide down like Tarzan. Because I was so active, my mother used to say, "Someday you're going to get married and have a family, but how will you make clothes if you don't know how to sew? You're just always playing with your brother." I was kind of flippant. "Well, Mama, by the time I get married, there will be a lot of clothes in the stores. So don't worry." Because I loved sports so much, I decided when I went to the University of California at Berkeley that I could be a physical education teacher. I didn't pursue that career, though.

I went to grammar school near Riverside in a big one-room building with one teacher, Mrs. Horton. She was a good teacher and very understanding of the Japanese and all students. She taught first grade through eighth grade. There were rows for each grade, with one row for first and second because she kept the youngest ones separated. They didn't have kindergarten, and they didn't have junior high. I learned a lot of things there. There were not too many children, so the boys and girls played together. We played baseball, primarily softball, and we ran races and played marbles, jacks, and jump rope. We had none of the modern equipment. If we wanted to make a bow and arrow, we'd cut down a willow branch and make the bow; then we'd string it. For the arrow, we'd pick a straight one and then put an acorn on the tip so we wouldn't hurt each other. We made little shields, and we'd pretend we were Cowboys and Indians and play like that. It was a relaxed atmosphere, with primarily Portuguese and Japanese and Caucasians. It was good because the teacher did not believe in segregating the different ethnic groups.

Sometimes on the way home from school, kids would throw rocks at us and call us dirty Japs. I don't know how many times I felt like saying, "You dirty Portuguese." But that was a no-no. My brother Tule, who was 14 months younger, would say, "Let's pick up some rocks and throw them back. We're not going to run." So we did. That happened several times, so I told my parents. I said, "You know so and so, they've been throwing rocks at us." My dad said, "What did you do?" "Oh, I picked up a rock and threw it back at them." He said, "That's all right to a certain extent, but you could hurt somebody. It's best to ignore it. Let them shout all they want. It's not hurting you. You hurt yourself by thinking that's bad for you." He always used to tell us that no matter what people did to us, we had to be nice to them—as nice as we could be. He believed in non-violence, so that's what he instilled in us. It was all right to stand up for our rights if what we thought was right. "But be sure that you're thinking clearly; it's up here," and he would point to his head. "And that's what matters."

One day I told the teacher that the Kessler children and the other ones started throwing rocks at us, and we threw some back. "But we can't keep that sort of thing

up," I said. Mrs. Horton said, "No, you can't." There was one streetcar that ran down the street, but there were mostly buggy wagons and very, very few cars. One afternoon, unbeknownst to us or to anybody, when she thought that we were quite a ways from the school, Mrs. Horton got on one of those streetcars and got off a block ahead. She waited for us, and of course it kind of frightened us because we wondered what a teacher was doing way over there. The Portuguese and Caucasian children were there too. She told them, "Look, you be friends. Just because she's different in color doesn't matter because she speaks your language. Don't say they don't belong here and call them names and so forth. Your parents probably came as immigrants many years ago, so what's the difference?" She said one's color is different only because he or she came from a different country. But she was very good in settling arguments in that fashion. Like my father and mother, she was a good role model. In the long run, we had a pleasant childhood with our Portuguese and Caucasian neighbors. We had fun, and when I look back at a few things like throwing rocks, there is no bitterness. It was child's play.

When I was 14, one of the teachers at the nearby junior college asked my sister to help take care of her father, a lawyer, while she was on a summer world tour with friends. My sister did a little cooking and caring for the house. When the teacher returned, she wanted somebody to help her permanently. So I asked my dad, "How about it, could I go to Miss Dunn's?" He said, "Yes. You might learn a lot there." They were well-to-do, and we were poor immigrants. She was a great person; she traveled a great deal and had gone to Mills College in Oakland. After the summer, I went to live with her, and she gave me a few dollars each month for room and board. Of course, everything was different. But I learned a lot of the American way of living by living with her: how to serve food, where the knife and the fork go—basic things. She showed me how to make a mahogany cake, which, to this day, I can still do.

I met my husband through a mutual friend after I graduated from college with my Bachelor of Arts degree. The friend was Kai Togasaki, a very respected businessman who imported Japanese items, such as dishes and clothing, and was well known all along the Pacific Coast. His younger sister and I were good friends at Cal. I had finished college, and I was helping on the farm because I felt I could be of more help than if I went to work as a secretary or something where you had to have a car to get to town. And then I could pay back some of my obligations to my parents. So Kai came over one time to talk with my father at the ranch, and he said, "Hey, Mutsu, I know a nice guy, my friend Saiki ("Sim") Muneno, and I wondered if you'd be willing to meet him?" I said, "Are you going to be a matchmaker?" He said, "Well, sort of. But he's college educated, and I thought maybe you two would make a good match." Shortly thereafter, Sim wrote when I should meet him, but I wrote back, "Look, Sim, I can't say yes or no." Later on, he laughed about how I had him sitting on the fence and how he expected me to meet him. I guess I frustrated him because he was used to having a yes and no answer. Since he felt he and I were a good match, it kind of upset him that I didn't give him an answer right away. Finally, one day he visited, and he seemed like a reasonable man, so we were married in 1932. Our marriage turned out to be a very even marriage, a give-and-take proposition. And we endured a lot during our marriage, especially in the beginning.

We lived in Pescadero after we got married; it's a small town just past Half Moon Bay, about 30 minutes south of San Francisco. After the United States entered the war in December 1941, we heard rumors for several weeks about the evacuation of Japanese nationals and American citizens of Japanese descent from the West Coast.

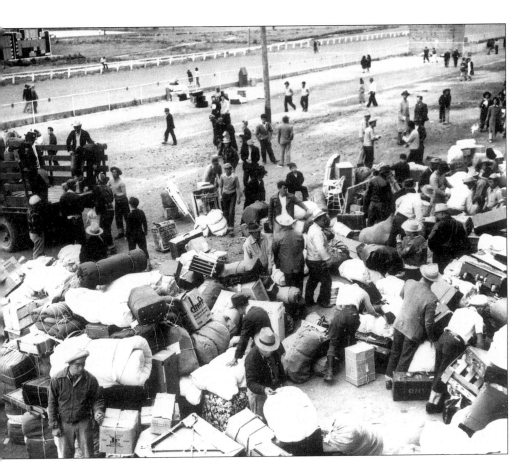

Among the indignities suffered by people at all the internment centers was sifting through mounds of luggage for the one piece of baggage per person they were allowed to bring. (Courtesy of the National Japanese-American Historical Society.)

On February 19, 1942, an executive order was issued, paving the way for the forced relocation of the Japanese. Depending on where you lived, you were interned at Manzanar (California), Tule Lake (Sierra Foothills), or Topaz, Utah, for those of us who lived in the Sacramento area. First, though, we were temporarily relocated to Tanforan, a horse track 10 miles south of San Francisco, while they finished construction at our permanent site. Of course we lost practically everything because we were only allowed to leave with one suitcase per adult. That meant two suitcases for a couple, and for the kids, we made a little satchel. That was all. At first I was very angry toward the government. We were citizens who were born and raised and educated here, paid taxes, and just because there's a war between America and Japan, my allegiance might go to Japan? Before relocation, the government sent out a loyalty form. The audacity of asking which country I was loyal to, Japan or the United States? I said, "You're crazy!" I was annoyed that the government seemed to be saying that even though we were citizens, since we were also born of Japanese heritage that would change our attitude and make us disloyal to America. I said, "Get that paper away from me," and I wouldn't sign it.

We had three children at the time, and they were very young. Another child was actually born during the internment. At Tanforan, we lived in the horse stables, because it had been a racetrack, so there was manure on the walls. We had our dining area under the stands, where people used to sit, and we called it the mess hall. There were barracks covered with tarp. We had just a tiny section for all of us, and my husband put up a sheet to separate an area for him and me. We had wrapped our luggage with lots of canvas, so he used that to screen off the area for us. It was maybe 6 feet by 3 feet, and I'd get behind there and dress, and we had our private things there. You'd think that the children were too little, but one day Sharon, one of my daughters, saw me back there, and it was my period, so I was putting on a Kotex. She didn't say anything at that time, but the next day, she got one, and she comes out from behind the curtain and said, "Eh, eh, eh, eh, put it on me." She saw it, and she thought that was the natural thing; she was only four, so she didn't understand. The bathrooms were right in the middle of the dining room, and they were open and divided stalls. The men and women were separated, but another woman right across from you was doing the same thing. Both of us were squatting and looking at each other because there was no privacy. Some of the ladies used to carry their own little curtains when they went to the bathroom. They'd tack up the curtains to have their privacy. You adjusted pretty quickly, and after a few days of being quite exposed and hesitant about going to the bathroom in full view, I thought, everybody else is doing it, so I'll just have to get used to it. But at first it was kind of tough.

We had to wash our clothes and children in concrete tubs in the bathrooms. I'd put all the kids in—four kids in four tubs, back to back. My son Hito, who was five or six at the time, was an active boy and always with a group of children. One day I told him that if he needs to go to the bathroom to say, "pee-pee" or "poo-poo." He said that he didn't need to go. Well, there were boards for the bathroom floor, and they hadn't been properly cured. So over time, they'd shrunk and opened up and there were spaces to the ground below. Hito found out that he could urinate there, and he would just 'pee-pee' through the cracks in the boards. He also hid my sisters' combs and hairpins underneath the boards; he thought it was fun to put one down and see if he could drop the other on it. Another time, Hito sat at the top of the stairs to the washroom watching the women with their bundles of laundry. They said, "Good morning," or some salutation like that. He found out that he could startle

them by saying bad words back. He'd say, "Oh, Goddammit," and I think that really tickled the ladies because he kept saying it. Until one day, when I heard him, and I said, "Hito, who are you swearing at?" He said, "These ladies that go by and say 'Good morning', and they're always laughing at me." So already he had quite an audience, and those ladies probably thought he was such a precocious child.

What was also interesting about being forcibly interned at the temporary shelter at Tanforan and later at the permanent camp in Topaz, Utah, was that many of the immigrant Japanese women had the opinion that they were having the time of their lives. Basically, they said, "Ever since we came to this country, we worked side by side with our husbands in the sugar plantations, at the pineapple plantations in Hawaii, on the farms in California. And we've never had, between raising children and working, we never had time for ourselves. And look at us in the camp. We're enjoying our lives; our food is cooked. We just have to wash our laundry, but everything is here. This is the first vacation we've had in many years." So some of them liked it. They weren't born here, so they didn't have to think in terms of how it was a disgrace for American citizens to be forcibly evacuated to camps by the government. So life at Tanforan and Santa Anita, a racetrack outside of Los Angeles that also served as a temporary shelter, was a holiday for them. And I don't blame them because as immigrant women, they worked hard. In the end, we adjusted to the situation of internment. It depended, in part, on the types of people we were and how we were raised. I always said, "We can make the best of this forced relocation." I didn't want to become calloused, especially when our children were growing up.

We went back to Pescadero after the evacuation because that was where my husband made his living. Pescadero was right near the ocean, and his ranch came right up to the edge of the beach, on a cliff. They raised peas, green peas, and they grew very well there because of the fog. They didn't have irrigation at that time, so they strictly depended on the fog to raise green peas, their specialty, and artichokes. But after a few years, the climates shifted, and the fog wasn't coming in as it used to. So they had to have a well to get water, and they started irrigation. But until then, for years my husband was dependent on the fog.

My husband was born in Hawaii, and he was an American citizen, so he could lease land, whereas people didn't lease land to Japanese nationals. So he and his brother could lease as much land as was available. They both leased three or four thousand acres and subdivided the land to the Japanese nationals. Then everyone could farm and raise peas and artichokes in large acreage. The Japanese nationals were grateful for that, and in turn, my husband kept their books for them, and he sold their products. Then my husband took a certain percentage from the crops as his share, and he got a certain percentage for the products at the end of the year. So he lived on the commission from the other Japanese tenants. He was a fair man, though. He wasn't one of these people who cheated anyone. And they were grateful for that because he was reasonable. They were able to farm because of him and his brother. Otherwise I'm not sure what they would've done because their children were too young to be left alone, and having land to work on meant the small ones could be close by, and they couldn't lease anything in their name.

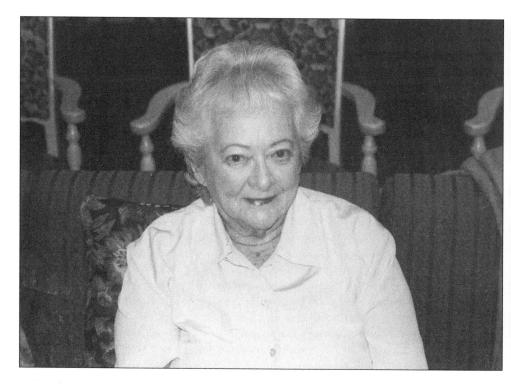

Sylvia Farber plays piano by ear, loves to paint, and enjoys quality comedy. This picture was taken in September 1999. (Photo taken by Steven Friedman.)

CHAPTER SEVEN
SYLVIA FARBER

Sylvia was born in San Francisco in 1916. Besides the city by the bay, she has only lived in one other place, Marin County. She did travel by train a lot as a youngster to visit her grandparents, who, for a short time, lived in Sacramento, but she has always resided in the Bay Area. Her parents were typical immigrants who worked long and hard and saved as much money as possible in order to assimilate into the fabric of American culture. And they found the time to enjoy what San Francisco and the Bay Area had to offer: parades down Market Street, family outings to Calistoga, concerts in Golden Gate Park, swimming at Sutro Baths, and a vibrant nightlife. She has vivid memories of her parents going out to Pucketts on Van Ness Avenue and Geary Street for an evening of good dining and dancing.

Sylvia grew up extremely close to her father and treasured the advice of her mother, and she's a wonderful hybrid of each parent. From her father, she developed a great sense of humor. She still remembers listening to his comedy records on the wind up record player and laughing to the antics of Charlie Chaplin, Jack Benny, and later, Mr. Television, Milton Berle. From her mother, she learned how to be independent and thrifty and to always be in a position to support herself. She would need all three qualities because she was widowed at age 40. After spending two months recuperating from a heart attack, her first husband, a San Francisco fireman, died in the hospital. Sylvia was left alone to raise their two children, Kenny and Barbara. She and Jack, then stationed in the Coast Guard, had met at a USO dance during World War II. They married in 1945, waiting until the war's end, and then Jack returned to his job at the fire department.

I met Sylvia and her second husband, Bert, at Drake Terrace in 1994. They were a cute couple, with a flair for humor and self-deprecation and a love of sports. And while they were capable of finishing each other's sentences or reading one another's thoughts, they also retained their distinct personalities. Sylvia was passionate about artistic endeavors, and Bert was extremely happy when he was glued to a ball game on TV. Even after Bert needed to be wheeled down to "Tea and Talk," he and Sylvia rarely sat next to each other—not because they wanted to avoid each other, but so they could mingle. I also never saw either of them get angry or upset— no small feat given the close confines of a retirement facility. Sylvia once told us a story about how she never believed in hitting her children. She preferred to remain calm and use reason and logic to show them their errors in judgment and behavior. When her son was four or five, she sat him down after he'd done something wrong. Sylvia began her usual speech, but Kenny soon interrupted, "Mom, can't you just hit me instead of talking so much?"

Sylvia exudes happiness and friendliness. She's dealt with the loss of her first husband and was widowed again when Bert died in 1998. I mentioned at one of

our interviews how upbeat and positive she's been about life, and she said, "I've always been a happy person, and that's what I tell people is necessary when they come into a retirement place. It's all about attitude, and my attitude has always been good. I've just accepted the bad things that have happened to me. Nothing bad that's happened has ever gotten to me; it's just in my nature to be happy."

Sylvia and her first husband, Jack, a San Francisco fireman who died two months after suffering a heart attack on the job, lounge on the lawn of Mark West Springs, a popular resort in Sonoma County. (Courtesy of Sylvia Farber.)

Sylvia (far right), Jack (far left), and their first child, Kenny (in the high chair), share a meal with her sister, Claire, brother-in-law, Irving, and their son, Stuart. (Courtesy of Sylvia Farber.)

I first lived on Naples Street, and then we moved to the Outer Mission by Geneva Avenue because my mother opened a dry goods store there. We lived at 5366 Mission Street, one block past Mt. Vernon Avenue and three blocks past Geneva. Geneva was the major street where you did big shopping; it's still there. In our neighborhood, there were two blocks of houses like ours that were built with the houses on top and the stores below; everybody lived upstairs and worked downstairs; that was what we did in those days. There was a bakery on the corner, and the man who owned it was Mr. Mangles. There was a grocery store on the other corner. And there was a man with a place that made hats, like sailor hats. Mr. Lansing. I haven't thought about him for 100 years. All of them were older than my mother and dad, and they were nice to us kids when we went in to buy stuff.

My mother's store was really a general store, where you could get almost anything you wanted: threads, stockings, ladies' things, socks, and underwear—anything you'd find in a variety store. And my mother also sewed and made clothes for people. In those days, you didn't buy clothes ready made; you had them made. She also sold materials so people could sew and embroider. We lived upstairs from the store in a house my folks owned; they never rented—not that I remember. My mother needed her job as a store owner to feel that she was somebody. She was a doer and a very ambitious woman. During the week, I was in school, but on Saturdays I would stay in the store. Most of the time, though, I played and was out with my girlfriends who lived down the street. My mother was always in the store, but if two people came in, I could wait on one. They might want a spool of thread, so I'd get a spool of thread. I think it cost a nickel back then. My mother was there all the time because we lived there. She had a small kitchen in the back of the store, and we ate all of our meals downstairs. We stayed downstairs because then my mother could cook and watch the store at the same time. She cooked and cleaned and everything else and still ran the store. If she were cleaning the house upstairs on a Saturday, my sister, who was four years older, and I would run the store.

My mother was from Russia. She came to America when she was eight years old, so she went to school here. She wanted to be an American. She never told anybody she was Russian. She learned to speak and read and write perfect English because she didn't want to be Russian. She wouldn't allow any language but English in the house. I didn't know for years that she could speak Russian. My father spoke some Yiddish, but not my mother. Her family suffered during pogroms [anti-Jewish riots] in Eastern Europe. Her father had to flee their home and hide in a hole some place just to get away from the Russian Cossacks [soldiers and villagers]. So she was 100 percent American; she voted every year of her life that she was eligible, right up until she died at the age of 91. When she moved here, she left her other life completely. She married my father when she was 17 and had my sister a year later.

My dad was a tinsmith, and he made garbage cans—anything that had to do with tin. He worked for a big company, Herbst Brothers, who were an important San Francisco family. Herbst Theater is named for them. He came to this country in 1902 from Romania when he was 17. He came to San Francisco by himself to join his brothers and sisters. I think his parents were here already, too. He came to the city just in time for the 1906 earthquake and fire. There are family pictures of when he and his family lived in Golden Gate Park in a tent. They stayed there awhile, until their house was built up, or they moved some place else; but they always lived in San Francisco.

I always wanted to be like my father and play the piano. My father was very

musical, and when Marian Anderson, the singer, came to the San Francisco Civic Auditorium, he took me. My father's family was also very musical. We used to get together and play music all night, and everybody would get up to do something—sing, play the piano. I get my musical talent from my dad, who used to play accordion in Golden Gate Park. He was an entertainer, but he played by ear, just like I do. I don't read notes, and my nephew can do the same thing—play by ear. I have a cousin who is in her nineties and still plays the violin in an orchestra.

My father was also a craftsman who made things at home. He made tin flower holders that you stuck in the ground at the cemetery. He made those down in the basement on Saturdays and Sundays for somebody else; it was a sideline business. And so I was always with him downstairs, trying to help him. I liked to do things with my father because he and I were real close. I was close to my mother, too. But I didn't like cooking, cleaning the house, playing with dolls. I **did not** like playing with dolls. I wanted a pair of skates. I wanted a bicycle. I wanted boy things. And I was my father's kid. Anything I could do with my father, that was great. But I should have been a boy. I was his son. My mother tried making a lady out of me, but it was a tough job.

My dad and I were also connected because he had a great sense of humor and was a comedian on top of it all; that's how I got my sense of humor. Both my husbands had great senses of humor, too. But it always was comedy with me. I always watch comedy. Even to this day, I don't like movies that upset me with tears running down your face and all that stuff. Not my cup of tea. It has to be funny. My dad had records of comedians from way, way back, and he always played them on a Victrola that you wound up with the dog on it. And then we used to sit by that and just listen to these comedy records.

Family was always a big part of my life, especially since almost everyone lived in San Francisco. There were so many of us that there was a standing joke in the family that if all the cousins ever wanted to get together, we'd have to rent the San Francisco Civic Auditorium. There were about five hundred of us. When we had weddings, when the cousins got married, there were two, three hundred people at each wedding. From when I was a little kid until I was 16 or 17, and I started working, my family and I went over to my maternal grandparents' house almost every night. That's what you did in those days. There was no television, and you didn't watch radio, so you went to visit family. My grandmother was in a wheelchair. I don't remember her ever walking, and as far as I knew, she was paralyzed. She was able to cook, and she lit the Sabbath candles every Friday evening. We were always over at their house to eat something; that was our way of life almost every night. Of course, she had a live-in girl helper that came from a home for wayward girls.

One time, when I was 16, one of my cousins came over. He had two little kids, and they gave me the job of staying with them and putting them to sleep. The kids were running around the whole house, and I was sound asleep. Anyway, family gatherings always included either food or music, sometimes both. We were a close family, and everything we did pertained to family. Everyone is almost gone now. But we had fun as kids. I think that's why I didn't have too many girlfriends, because my cousins were my girlfriends.

Our family went on a lot of outings. We used to drive over to Marin. We'd drive to the ferry building where we had to put the car on a ferryboat and end up in Sausalito. When we went home, it would be crowded on the roads to the ferry in Sausalito, and you had to wait to get your car on. We'd have to go up all the hills and climb down

Sylvia and her second husband, Bert, whom she married in 1963, relax after a meal with her daughter, Barbara, a cousin, and Bert's stepson, Kenny (wearing glasses). (Courtesy of Sylvia Farber.)

the hills before you could get to the ferryboat. That was fun for us kids, but I don't think my father liked sitting in the car and waiting in traffic. There were places in Marin to swim and whatnot.

Or we'd drive up to Calistoga where they had the baths. My parents loved the swimming baths up in Calistoga. There was all kinds of swimming, and they had the geyser that shot up in the air. It's a place where you swim all day, and at nights, you'd go to bed. There's nothing much else to do. We did go out and eat. We didn't soak in the mud as much as we went into the hot springs or mineral baths. My mother would get in the water, but she didn't swim; my father did. He was the first one who taught me how to swim when we were at the lake in Los Gatos, which is about an hour south of San Francisco.

My dad also used to take me to baseball games because I liked sports. He took me to see the San Francisco Seals, who played in Kezar Stadium over by Golden Gate Park. We also took the ferry to Neptune Beach in Alameda. We bought lunch there and went swimming. Also, our family used to go every Sunday to hear music in Golden Gate Park. In between the De Young Museum and the fish aquarium is the

bandshell, and there used to be a band of 50 musicians. These concerts were very important, especially since my father was so into music, but everybody there loved it. I started going to the concerts when I was two years old. Our family also went to a lot of shows at the theater, like the Warfield on Market Street, and to the nightclub El Capitan out in the Mission District. Jay Brower, a San Francisco boy who'd made it good, was always at El Capitan with his band.

When I was older I went out with my friends. We used to take the streetcar and go down to Fifth and Market Street. Hale Brothers was on one side and Emporium was on the other side. We used to go there, and those were our favorite places. Hill Brothers was where my mother worked when she was 16. We also used to go to Woolworth's 5 & 10, and we'd get tuna fish sandwiches on toast. That was the big treat when we were 14 or so and could go out by ourselves. Everything we did was on streetcars, so I rode them a lot. The streetcars went right by my house, so it was no problem. We also went to Lurlene Pools on Columbus Avenue. The indoor pools were right around the corner from the Bal Tavern, which was a big night club. We also went to a lot of parades in the city. My parents had some friends—the Molokipis family—who owned a big brewery out in the Mission District. We were very close to them and went everywhere with them. They used to take us on the back of their big brewery truck, and we'd see everything during the parades.

My parents were never rich people, but they always had money. My mother was a saver, and my father always worked, as did my mother. My mother also bought and sold property. In those days, if you made $1 a day, you lived on it. My parents, my sister, and I used to go shopping every Saturday night on Fillmore and McAllister Streets to buy all the Jewish food. My dad drove us all down there, and we got lox and bagels, chickens, and herring. The Langendorfs had a bakery there, and there was Haz's ice cream parlor, a beautiful place with chandeliers. It was a nickel an ice cream cone, and I always had vanilla because I'm a very plain person. I recently read an article that said vanilla ice cream people are boring, but I don't think so. I **like** vanilla ice cream.

There were many Saturday nights that we came home and ate the lox and bagels before we went to bed because we couldn't wait until morning. My mother always bought her chickens on Fillmore because they were alive, and she could pick out the one she wanted; that way she knew it was fresh. She was a very fussy lady. She would pick it out and then come back after the butcher had killed it. We ate chicken two or three times a week. She used to buy corned beef where they'd slice it real thin. My mother went into the big barrels to get the herring. She'd pick out the dead fish. Sometimes she bought it smoked, and then take it home to marinate it or do something else with it. She'd marinate it in vinegar and olive oil and then chop up some onions and let the whole mixture sit. I never liked herring, but we had it every Sunday. My parents went down to those streets to get kosher food, but my mother did not keep a kosher home. She mixed milk and meat, which is against Jewish dietary laws, and we didn't always have kosher meat. My grandmother was religious, but my mother wanted to be an American. I don't know why my mother didn't keep up some of the Jewish traditions that she grew up with. She just did what she wanted after she got married; she was a very independent person.

My mother was the disciplinarian. My father didn't care about anything like that. His attitude was, "Let's have a good time, play music, and be funny." I don't ever remember breaking the rules that much that she could've found out about it. I broke a few rules, but she never found out. A group of us—boys and girls—used to go to

high school football games at Balboa High School. We used to get into somebody's car and just go. I'd say to my mother, "I'm going to a football game today, on the streetcar." I was 16 or so, and it was okay to go to the games on the streetcar. But you don't get into an automobile with a boy; that was my mother's rule. So we'd meet up somewhere, take the car to the game, and after, they'd let me off two blocks from my house. She never found out about it. But she was strict. When I started going out at night, I had to be home at midnight or ten o'clock, and I was always home at that time. I was a good little girl.

The other rule I broke but didn't get caught at was when I joined a bicycling club. We got together on Sundays and went riding to different places. A group of girls who had bikes just started up the club one day. Somebody would tell somebody else about our plans, and then we all got together. I did that for about a year. We'd meet down at Ocean Beach and take a ride down to Half Moon Bay, a good 25 miles south. That was a good schlep [hard work]. When we got there, we had lunch, or sometimes we brought something to eat on these rides. But my mother didn't think girls on bicycles were ladylike. She tried real hard to make a lady out of me, but she couldn't start telling me what to do then; I was already 19 or 20 years old. She also wouldn't let me have a bicycle because she thought I'd die if I were on a bike. But I rebelled. I would tell my mother that I was going out with my girlfriends.

I formed the bicycle club with a group of girls who were beauticians. When I got out of high school, my mother asked me, "What are you going to do?" I was not a great student, mostly Bs, but I never flunked out of anything. I did arithmetic and math, but it didn't sink in. I was into music, harmony, singing, so I joined the girl's chorus. Everything was art, and I loved it. I was into painting, knitting, and needlepoint. I just wasn't an A student like my sister, the valedictorian at Commerce High School, who skipped two years and graduated at 16. So I said to her, "I don't know what I'll do." Well, my mother had a friend who was a beautician, and after I talked to her I decided to go to California Beauty College on Fifth and Market Streets. My mother said, "You'll like beauty school. You'll be able to do things with hair." It sounded like a good idea, so I went there and loved it. It was just a continuation of art. I had to take a state test before I could get a license. And that was pretty tough, and we worried ourselves sick about it. We had to bring our own model to do her hair as somebody watched. We had to pass the whole test. After I finished school and passed the state exam, my mother helped me buy my own salon. She said, "You don't work for somebody else. You go into business for yourself."

So I got my own shop when I was around 18, and I had it for ten years, until I got married. It was called Sylvia's and was located at 24th Avenue and Vicente Street, just two blocks from Taraval Street in the Inner Sunset District. I charged a $1.85 for a permanent, 50¢ for a manicure, and a shampoo and set was a $1 and a quarter. I didn't do pedicures. We didn't do that in those days, and I didn't like feet work. I never went in for that. Don't like feet. I don't like other people's feet. I don't even like my own feet. People used to ask me for a pedicure, but I said, "No, I don't do it." I did hands, but that was it. Feet did not come into my life. Mostly I worked alone, but when I got busier, I had a girl working with me. I had the shop during World War II, so I used to buy war bonds; I was very patriotic like my mother. I also earned good money, and I was a saver. As I already mentioned, my mother was the businesswoman in the house. She bought a house out in the Sunset close to where I had my shop. Then she bought a house at 38th Avenue and Lincoln Way. There was a house next door for $6,000, and so she wanted me to buy that one. I said, "What

do I need a house for. I'm not married; what do I need a house for?" I didn't let her talk me into buying it, and that was stupid on my part. I should've kept it and sold it for $10,000 because that's what I could've done. I was foolish not to. My mother was smarter than me.

When I was in grammar school at Longfellow, near my mother's store, I liked boys better than girls because boys did things, like baseball and football. They played sports, and I liked that. By the time I got into high school, I could go out on a date as long as I brought the boy home. My mother always had to meet them. I didn't really date, though, in high school. It was different in those days. We used to have a lot of dances at Balboa High School. The school band would play, and we always had them in the gym. All the kids met there when school was out on Fridays. The teachers chaperoned, and they were very cooperative. The dances would be like a date. If you danced with one boy the whole time, you were practically going steady. It was a big deal when one boy wouldn't let you dance with anybody else. Slow dancing was all we did. We didn't do any dancing like they do now. I know I swing danced, but I think that was not part of school. At the school dances, we danced waltzes; we danced foxtrots. We danced close, but not like today; we were much more conservative. They were late afternoon dances that lasted about two hours. I got home by six o'clock; I took the streetcar.

Then I used to go to dances at the Jewish Community Center on California and Presidio. It was hard for me to get to the JCC by myself because we lived out in the Mission, and I had to take two streetcars to get there. I only went to the JCC dances when my dad used to drive me and take me home. My older sister already had a boyfriend, so when I was 14 and she was 18, they used to drag the little sister along. I was a "drive-along." That's what they used to call me, the "drive-along." That was the pesty little sister. We went together to dances at the Jewish Center, and then they would drive me home and go out by themselves.

I did go to a prom when I was in high school, with someone who later became my second husband, Bert Farber. He was a friend of mine from Balboa High. I think it was his prom because I was probably a junior, and he was a senior. We went to the prom, and we went out afterwards. But then we didn't do like the kids nowadays. You went to a prom, and you never went out again. I don't think I ever went out with Bert again. We were just friends, saw each other at school, that was all. It was pretty simple. Bert asked me, "Would you like to go to the prom with me?" I said, "I'd love to go to the prom with you." Then I got a dress, and he got me a flower, and we went to the prom. He was always a nice guy, always a gentleman. Our paths parted after high school—I got married, and he got married. I used to see him because we lived in San Francisco, and we lived near each other. One time I took the bus with my daughter, Barbara, and I met him, and he talked to her, and that was about it for many years.

Years later when I was a widow, I belonged to the sisterhood at Temple Shearith Israel, which is on California and Webster Streets, and they were having a dinner dance at the Fairmont Hotel or some fancy place. I didn't have a partner, so I wasn't going to go. At one of the sisterhood meetings Nida Caan said, "I want to introduce you to somebody, Sylvia." "Who?" "Bert Farber." I said, "I went out with him when I was 16." She said, "Well, he's single now, and you're a widow, so I'll introduce you to him." She got us together on the phone, and we laughed about it because we'd been in school together. Then I said to him, "What are you doing Saturday night? There's a dinner dance for the Temple, and I haven't got a partner." He said, "Oh, I'll

go with you." So that's how we got together again. But we went together a long time after that. We were in different clubs. We used to call them the widows and orphans clubs. But they weren't. The clubs were just single people, maybe second marriages or divorced or widowed or whatever, and we used to meet at different places. After that, Bert went with other girls, and I went with other fellows. Plus I had two kids to raise; I couldn't go out every time I wanted to. Then all of a sudden the kids got older.

I don't remember how we got serious, but I think it was when both kids went to a party one night, and I was sitting there alone when he called up, and I said, "I'm sitting alone, you're sitting alone, let's go out." Then we started dating seriously, and later we decided to get married. Bert and I dated for five years, and we didn't get married until I was 46. I think I was serious about him and not someone else because of my mother. She was very influential in my life, and she said, "Bert is a good boy. You'll always have something to eat. He will always make a living, and he is a nice person." So I said, "Well, my mother likes him, he can't be bad." We got married at Temple Shearith Israel, and we had Bert's son and daughters stand up for us on his side and my son and daughter stand up for us on my side. We didn't have a big wedding; we had a total of 10 to 15 people, and we were married by Rabbi Goldstein in 1963.

Bert had a coffee shop—Bert's Coffee Shop—on Montgomery Street in the Financial District in San Francisco. He had to go to work at four in the morning because he opened at five. He catered to all the brokerage houses and served them breakfast, and they all went to work at six. He was through work by three in the afternoon and was home by four or four-thirty—before all the commute traffic. Of course the traffic wasn't bad in those days.

Bert and I enjoyed doing a lot of things together. Before I'd met up with Bert again, I'd belonged to a swim club in Marin County but lived in San Francisco. I sold the San Francisco house and bought a big one in Terra Linda, which is a neighborhood in San Rafael [Marin County], about 20 minutes north of the Golden Gate Bridge. But then I decided that the club was too husband and wife-ish—and I was alone. So I sold the Terra Linda house and moved back to the city. Bert and I were only married a year when we moved to Marin because he liked it. We joined the swim club. One of the first things we did every weekend was to go to the club. It was really great for our kids. We swam, ate, played bridge, and met a lot of people we liked. Bert was an expert bridge player, and he went swimming just about every Saturday and Sunday.

Bert and I also took up square dancing. The best part of square dancing is that they tell you what to do—take two steps to the right, two steps to the left—and you're a square dancer. But I'd been a square dancer for many years. My first husband and I square danced together, and then when Bert and I got married, I said, "Would you like to try square dancing?" He was a good dancer, so square dancing came easy to him. We had many wonderful years with a great group of people. In fact, we danced at the Mountain Play one time. The Mountain Play is held each summer for several weeks in an amphitheater on Mt. Tamalpais, which overlooks most of Marin County. They were putting on *Oklahoma,* so they asked our square dance group—The Tam Twirlers—if we would dance before the show. Bert and I square danced for 12 years together, and that was the most fun in my life; it was just great.

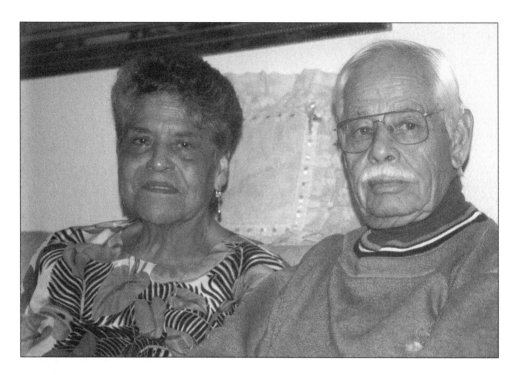

Ciro and Esmeralda Contreras bought their current home, which was three doors away from her parents, in the early 1950s. They are pictured here in September 1999. (Photo taken by Steven Friedman.)

CHAPTER EIGHT
CIRO AND ESMERALDA CONTRERAS

Ciro and Esmeralda Contreras live in a modest home in a middle-working-class neighborhood in Hayward, California, an East Bay suburb located about 50 minutes from San Francisco. They bought the home in 1951, and he began remodeling it in 1957. Due to his full-time job, he only worked on weekends, and he only worked when he and Esme had the money for a particular task—he also wanted to remain debt-free. It took Ciro ten years to finish the additions and expansion of the home they've occupied for almost half a century.

Ciro's ability to do the work came naturally, for he was trained as a carpenter in his native Mexico. Born in Zacatecas in 1920, he left for Mexico City in search of a better life when he was 16. He felt there was no economically satisfying future in his hometown. "You had a future there, if you were working in the mines, but my father would never let me do that. I worked with him in the carpentry field." He made money in Mexico City, and he sent much of it home, but he still had few opportunities for long-term economic security. He migrated to the United States in 1943, one year after the United States and Mexican governments initiated the Bracero program, which brought manual laborers into the country to alleviate shortages on farms and maintain the railways. Because of pressure from farmers in the Southwest and California who relied on the cheap and imported labor, the Bracero program was renewed until 1964. He was a farmworker from 1943 through 1949, when he took a job in a San Francisco hotel. He still harvested and planted periodically—even though he was employed full-time at work that was not farm related—on California farms for a couple of years more, helping out his father-in-law and his wife's other relatives in the Salinas Valley.

Esmeralda is a California native of Mexican descent who was born in 1927 in Van Nuys, which is just outside of Los Angeles. Her family desperately searched for work on the eve of the Depression. Because of the harsh realities of life as a farm laborer, she had little formal education but made up for it with an invaluable commitment to her family and the jobs they did to survive. She was an all-purpose worker who did whatever was needed by her father and others. She planted, harvested, cooked, hauled wood and water, and drove tractors and trucks. She found little time to relax until she was in her mid-teens, and she was no longer in the fields but was helping to contract and supervise the workers for her father.

I didn't meet them until the day of our first interview. About a week earlier, my wife had come home and told me that the parents of one of her paralegal colleagues at the city attorney's office in San Francisco were former farmworkers whose stories of toil under difficult and often inhumane conditions during the 1930s, 1940s, and 1950s were straight out of The Grapes of Wrath. *I called them that same day, and they instantly invited me to their home. Although slowed by a stroke he had seven*

years ago, Ciro Contreras can be found on most days—weather permitting—in his yard, tending to his plants and garden; he was out back among the shrubbery on the sunny day I arrived for the interview. Mrs. Contreras walks stiffly now as a result of too many years bent low to the ground. Although she is receiving treatment for her back, she still prides herself on her home and kitchen and the activities she's involved in with her children and grandchildren and church.

They are proud of their Mexican heritage and proud to be Americans. They also enjoy sharing stories of their days and nights as farmworkers, even though many people they know don't believe anyone ever worked that way in this country. But what struck me almost from the beginning of our conversations is how they are so family oriented. Ciro still sends money to his sister in Mexico, and he helped each of his four children purchase property so they could become economically self-sufficient. Esme can count over 600 relatives, mostly cousins, on her side of the family, and she enjoys orchestrating large family dinners (15–30 people) on a semi-regular basis. They are also very giving people outside of family. On my second visit, their home was filled with a few dozen bottles of Rumpop, an eggnog libation prepared by a group of local nuns, that they were selling to benefit these church sisters.

They are a wonderful combination of people who remember the past but forge ahead into the present and future, not because they are ashamed of their roots, but for a better life for themselves and their loved ones. I think this point is best illustrated by a story Mr. Contreras insisted he tell me, even though it was not a direct answer to a question. He was nine years old, and his father had an order to make a wooden handle for a hatchet of a customer. His father charged 35¢, Mexican money, for the job. That money was crucial; 25¢ was enough for his mother to buy meat to make soup for the family, who was somewhat poor. After the job had been completed, his father returned home, and his wife asked him for the money so she could go to the market. "Woman, you saw me get up at four in the morning to make the handle, and the customer promised to pick it up. He didn't come yet, and the hatchet is waiting for him. I won't have the money until he comes." Ciro just listened, and then went to help his father, whose carpentry store was located on the other side of the family home. An hour later, his mother reappeared to tell his father that she needed money now because the meat market was about to close. His father said, "The hatchet's still here. He didn't come and pick it up. If you want, pick up the hatchet and make soup out of it." At that moment, Ciro decided that he never wanted to be in the situation of depriving his family of money or food. He knew his father had little choice, but the incident made a young Ciro want to grow up and be able to support his loved ones.

Ciro, who came to the United States from Mexico in 1943, worked in the fields throughout the Salinas Valley for nearly eight years. (Photo courtesy of Ciro and Esmeralda Contreras.)

Ciro

I came to the United States from Mexico City in 1943. I came through the Bracero Program to Greenfield, California, which is near King City in the Salinas Valley. It is about 90 miles south of San Francisco. My first job was picking beets. Maybe 90 to 95 percent of the workers were Mexican; many were not married. Eventually, I picked all kinds of fruits and vegetables. When I picked tomatoes, I would take my pants off at night, and they'd be stained. We moved from camp to camp. Once they had too many people working in one place, they moved a lot of us around to another field. It was especially hard for me because never in my life had I worked in the fields; I was trained as a carpenter. Get up and breakfast was in the dining hall of the camp, and a truck was ready to take us to another field. Get to work at six, sometimes seven, in the morning. We had two or three breaks during the day, and we stopped for lunch at noon. They brought us food and water in the fields everyday, and we could use the bathrooms if we asked permission. Next morning, the bathrooms were always clean.

We worked until three or four in the afternoon, sometimes six at night; it all depended on the work we had to do. I needed to stay here and earn money to send to my family back home; my father barely survived in our home in Mexico. I think I was working for peanuts, but 65¢ an hour was pretty good money moving from Mexico. So I didn't pay attention to the conditions, but it was hard to get accustomed to working in the fields and living in the camps with only men. There were anywhere from 10 to 20 men in each barrack. We had good food and a table to eat on. If it was raining hard, we didn't work. And in the wintertime, when there was not much to do, it was weeks and weeks of nothing.

The people running the camps were paid by the government, so the government supervised all the food and the inspections of the barracks. Sometimes they hired people from Mexico who could cook the same things as I cooked in my house. Once an inspector came unannounced to the camps and found the conditions were very good. How we lived depended on us keeping the barracks clean. One time, the foreman came and saw that the barrack wasn't clean; he gave us a bad time. Only one time did anything bad happen to me. I was at the hospital for a month during 1947 because the spray from the fields got on my head. I didn't use a cap because I didn't like a cap. I couldn't stay out of the sun because I like the sun. But I started to use a cap because that's what the doctor prescribed. Overall, though, I think the situation in the 1930s and 1940s for farmworkers in government-supervised camps was better because the families who supervise the fields now are not supervised by anybody. After I got married in 1949, I left my wife to go work up in Santa Rosa, 40 miles north of San Francisco, to help her mother and father, who were running a camp for farmworkers. I was really surprised to see the conditions they lived in. Theirs was not a government camp, so the conditions were bad.

After work, we might wash clothes and hang them to dry in the sun. Every Saturday afternoon, there were Mexican movies in Soledad, just a little farther south of the camps. I went into Soledad because I only understood Spanish. Sometimes I went there for Sunday dances because I love to dance, mostly the jitterbug at that time. It was public dancing, open to anyone, but most of the people were Mexican because they played Latin music. The bands came from Mexico. Believe me, I was a better dancer than many of the ones who were there.

I stayed in Greenfield from September 1944 until August 1945. I moved to Salinas

Esmeralda and Ciro are both very committed to Catholicism, and she received her first communion in 1933 at the age of six. She is pictured here in her communion outfit. (Courtesy of Ciro and Esmeralda Contreras.)

Mrs. Contreras (far right) labored in the fields as far north as Santa Rosa and as far south as Salinas. She learned to pick every type of fruit and vegetable grown in Northern California, and to drive a tractor. (Courtesy of Ciro and Esmeralda Contreras.)

because the company I was working for—Union Beets—moved there. They paid the people to move. Our supervisor was Manuel Jimenez, who worked for the company, but the government oversaw him. I went back to Mexico in 1947 when the Bracero program expired. Many people left the camps early because they didn't want to go back to Mexico. Matter of fact, I escaped the camps, too, because I didn't want to go back. But many reasons in between made me go back. I think my grandfather died, and though I don't remember exactly, I decided to go to Mexico. I could not make a living in Mexico, so in January 1948, I started to prepare to return to the United States. I loved it here, and I was coming back for that. It was better here than the conditions in Mexico—as simple as that. I returned to the Salinas Valley in March 1948, to a place that knew me very good. The owner of one of the fields I worked in as a *bracero* hired me back. He hired me back, not the government, so now it wasn't a company but a family—his family. He ran a few ranches with other farmers. He was German, and he and his family were very good people. I worked on a big ranch. We harvested and planted everything—beets, tomatoes, lettuce, and other vegetables, all kinds of fruits.

I had a girlfriend I'd met when I was in the Bracero Program. After a while, I didn't see her too much after her family moved to Half Moon Bay, about 1½_ hours north of the Salinas Valley. Maybe she wasn't interested in me, and I lost track of her. I wasn't able to see her because I didn't drive. I knew how to drive, but I didn't have a car, and I didn't have a license. I just stayed in the camp of the German family farm, working almost 12 hours a day. They started me on irrigation. We were working long hours, but the job wasn't as heavy as picking lettuce, beets, and all those things. We just put the water in the fields in the morning and sometimes at night. We spent the day watching how the water was running. The work was easier, and the pay was better. I was paid what at that time was very good money. I just kept what I needed for survival. I sent the rest to my father, sometimes two, sometimes three hundred dollars a month. I was proud to be a good son. Besides, my father was too old, and he was depending on me.

I started dating Esmeralda in 1948, when she was helping her aunt and uncle, who ran the kitchen, in the camp where I was working. I had a Filippino friend, and he gave me the background on her. He said, "There's a beautiful senorita working in the kitchen." I said, "Yeah, I saw her." Then I used to tease him, and I told him, "This senorita, she told me she likes you. She is beautiful, and she likes you." "Oh, no," he said. He liked hearing stories, made-up things, so I took advantage of that by teasing him about Esmeralda. I don't remember how she and I first got together, but it was my luck and her luck. I'd already moved to San Francisco when we started dating, and I came to visit her when I did seasonal work in Salinas.

In the winter of 1948, when I had nothing to do in the fields, I wrote a letter to a friend in San Francisco, and he invited me to live with him in the city. I started working at the Palace Hotel, cleaning dishes and so forth. San Francisco was very good; I was working everyday, getting good food, in clean clothes, and it was not Salinas. I made about $30 a week, plus free meals. The hotel people saw that I was interested in working, and I spoke a little of the language, so they moved me to busboy. When there were conventions at the hotel, I served the tables. We lived in an apartment in the Mission District on Eric Street. It was government housing.

Esme and I got married in February 1949, and we moved right away to San Francisco. We lived in a duplex on Folsom and 21st Streets that we shared with my friend Roberto, Roberto's friend, my cousin, and, soon after that, the two sisters of

Roberto. It was a big house, with the bedrooms upstairs and the living room downstairs, that we shared. We paid $550 a month. We didn't stay there too long, but moved to another apartment, that Roberto and I also went in on, on Eureka Street. The group of us liked to go out in San Francisco to dance. Sometimes we went to the Sweets Ballroom, which had many bands from Mexico every weekend. We liked the big bands: Louis Salkaras, Sonora Santanera, and the Cuban, Xavier Cugat. As my wife said, "The New Year's dances were the best. A lot of us—the couples, my sisters and their husbands, cousins or godparents—would get together and go out and have a ball."

Her family didn't like me at first and practically nobody, from her relatives, came to our wedding because I came from Mexico, like her family, and maybe they thought someday I'm going back there and I'd take her. Maybe they didn't think my way of life was different than theirs, and if I took her to Mexico, they thought, we'd live in worse conditions than right here. Besides, I wouldn't earn enough money for her to come up from Mexico to visit her family in the United States. But I didn't want us to be strangers in another country like what I was when I first came to America. Her father, though, was pretty sharp. He didn't have good schooling, not even in Spanish or English, but he had a good heart and a pretty good mind. He saw something in me, and he loaned me $500 for a down payment on the house we've lived in—in Hayward—for almost 50 years.

My first job after we got married was at the State Battery Company in San Francisco, located between Howard and 14th Streets. The factory was in a small alley. I started packing battery plates that we'd send to Korea during the Korean War. I liked working at the hotel, washing dishes every day, but I really liked my trade. I wanted to work as a carpenter some place, but I found a job working with batteries. In 1950, I was laid off, but they recommended me to another plant. The other plant was in Oakland, and I worked there for 32 years. One of the first people I met was the owner of this company, Mr. Stillman, who was a Jewish. I presented the recommendation from the other company to him, and he asked me, "Are you Mexican?" I said, "Yes. Why?" He said, "Because I have so many Mexicans with me, and all them are drunk, and their working style got pretty bad." "Well," I said, "I didn't come in here to know the background of my fellow Mexicans. I came in here because you needed somebody to work, and I got a good recommendation. If you want to hire me because I know the work, that's okay. But if you hire me because I am Mexican, I don't want the job. He said, "When do you want to start working?" "If you want me to work tonight, I'll work tonight. I need work." I started the next morning.

Esmeralda

There were 11 children in my family, 6 boys and 5 girls. The oldest ones started working when they were 14 years old. We younger ones started working at 14, too, and kept going. As it was, we only went to school to the eighth grade. We went to see the high school where we were supposed to go, but we never went there because we were following the harvest in different places. My aunt, my mom, and my dad used to work in the fields because, at that time, there was nothing else they could do, and none of them had an education. We left Los Angeles County and came north to San Jose when I was seven. We moved around a lot, from the Salinas and San Joaquin Valleys to Russell City, which was a poor section of Hayward where Mexicans, Blacks, and Puerto Ricans lived. From Russell City we went to work in Tracy, Livermore, Fairfield, and Stockton. We also worked in Fremont and San Ramon, which are near Russell City, and as far north as Santa Rosa and Healdsburg in Sonoma County. We picked everything: apricots, pears, apples, prunes, cherries, grapes, walnuts, broccoli, cauliflower, lettuce, carrots, onions, and tomatoes. There was always enough work to do; just in the winter, when the work was too hard, and it was cold and raining, did we take a break from working in the fields and orchards. My dad would say, "Let's try to save our money during the rest of the year, so we won't have to worry about everyone working during the winter." Then he would go out in the winter by himself. But there wasn't much fieldwork, so he got paid helping out at pool houses where they had gambling and cards.

We were very poor, but we always had plenty to eat. Anywhere my dad went he came back with something—vegetables, fruit, meat, or milk. They used to make good sandwiches at these pool houses, and if they didn't sell them all, they'd give them to my father for us. We lived in little shacks in the farmworker camps. Most of them had no running water, no stoves, and no washing machines. The women had to do everything by hand. There were little wooden stoves, but they'd have to carry the wood and water from wherever they could get it, or the men would bring it. The women had to cook and boil water to clean the clothes at the stoves. Since there was no running water, all of us, even our cousins, bathed in the same water so we wouldn't waste it. Then we would each rinse ourselves with clean water. When we camped in San Jose, though, there was running water from a well. The bathrooms were outside—just a wooden shack and a pit. All of us couldn't buy shoes at the same time because there wasn't enough money. Same if we needed clothes; we had to take turns to get anything. I remember we had some shoes that from the top looked real nice, but on the bottom didn't have soles; they were worn out. We put cardboard on the bottoms, and we wouldn't lift our feet. We were a happy family, regardless.

During the Depression, when we lived in Santa Maria (outside Los Angeles), it was hard for my parents and relatives to get work in the fields, but we survived on cactus and beans. Other times, my father was able to buy some cows, goats, ducks, and chickens, and he killed them so we'd have meat. Or he'd buy things like flour, beans, and rice in sacks, or lard in bulk. That way, we'd have enough to survive on in the winters. And my mom used to can vegetables to use in the winter as well. Plus, she never spent money foolishly on herself, and she never really wanted to buy anything for herself. She never even wanted to go to a movie. My dad would say to my mother on a weekend, "Don't cook today. Let's go out to have something, not very expensive, but let's go get something to eat." Well, we were working, all of us, but she never wanted to come. She said, "No, no, no, that money will be helpful later

on." She was a good little saver, so if we needed it, it was there.

Sometimes we had to leave our camp in the Salinas Valley by four in the morning if we were going to Stockton or San Jose. We picked mostly prunes in San Jose. When we went farther north, Santa Rosa or Healdsburg in Sonoma County, we would stay at the fields and orchards. Those bosses were the best; they were nice people. They provided nice cabins with running water inside. Of course, it wasn't hot water; it was cold, and the bathrooms were outside. Each day at noon they would bring us sandwiches and sodas and all kinds of things. Every weekend they would kill a calf or something like that and barbecue plenty of food that they'd bring us. They appreciated and were happy that we were doing the work for them.

We learned a lot about how to pick fruits and vegetables. If we worked by the hour, we would try to do it the right way—taking your time—because there was enough time to do the job. But it was easier if we got paid by the bucket. Then everyone would try to hurry so that we could make more money. When you were picking, say, apricots, you set your ladder, and you would always set it in a place where you could get more. You set the ladder in the middle of the tree so you would get to one side and then the other side, and then you would pick the apricots on the top. That way, you wouldn't have to be moving your ladder so much. Because if you would put it in just one spot, you would only get that area, and then you'd have to move your ladder. When you picked efficiently, that was the way you got more money, more buckets out, and more food.

Cherries were the same way. With cherries, you had to use those extension ladders (cherry pickers) because the trees were so high, especially when you're in Crow Canyon, which is over here by San Ramon. Those trees were—oh my—huge. You'd get a 40-foot ladder extension, and you would have to set it right and tie it up. You had to tie the ladders to a sturdy branch in order to make sure they wouldn't come down. Imagine, you'd be out there more than 20 feet up in the air, picking those cherries. And you had to do it the same way as apricots, placing the ladder in the right spot so that you'd pick a lot. Sometimes you'd get about ten buckets out of each area where you had your ladder because there were so many cherries. And then, they were those big nice cherries. So you'd make good money, but it was hard work, out in the sun and timing those ladders. Who would have thought that I'd get even 3 feet out by myself? I was afraid to fall. At that time, though, I was over 20 feet up in the air. My dad or somebody else would help us set up the ladders in order to tie them up because they were heavy. Thank God we never had any problems with them coming down or falling.

The hardest work we ever did was with the short hoe [which has since been outlawed for use by farmworkers]. You had to hoe by hand from one end of the row to the other. You had to crouch down and use the hand hoe, not even a long-handled one, and till the soil. That was the hardest work we ever did and the kind I hated the most. I cried. And it was so hot. We didn't want to be standing all the time, because if you did, it would be worse on you. So you'd start out crouched low on your back until you got about a half-mile. Then you would straighten out, and you would look back and then start again until you finished another portion. You'd do an acre a day, and an acre of that kind of work was hard. Many of the other workers wondered how we Garcia (our last name) girls were able to work so hard. A lot of them didn't want to work with us, and they said, "We don't want to go to the camp where Esme and Mary are. Those girls will kill us by making us work so much harder. They work like nobody's business." Well, we didn't do that very much. We did it maybe a couple of

Mrs. Contreras (far left) found little time to socialize with her sister and cousins under the watchful eyes of her strict mother. They either had to harvest the crops, cook for other workers, manage farmworkers, or try to attend school. Occasionally they were able to go to the movies or sneak out to a dance. (Courtesy of Ciro and Esmeralda Contreras.)

seasons because I guess my dad realized that it was too hard for us. That's when he decided it was better to have a crew working for him instead of having us do all that kind of work.

At the beginning, he wasn't a contractor; he was just a regular working fellow who picked fruits and vegetables. Then he decided he would go into being a contractor. My grandfather had been a contractor, the person responsible for hiring the workers to work the fields and orchards. That way, we wouldn't have to work so hard. And that's when my sister, Mary, who is four years younger, and I started helping him with all the workers.

When I was about 15 or 16, Mary and I didn't do as much picking and harvesting, but we ran crews of 50 or 60 men. We watched over them to make sure that they did the work good. Then, when they had buckets of apricots or cherries or other things, we used to punch their cards every time they brought a bucket in. Or the cards might also have the hours, if the men were paid that way, and the names of each person so that when the week ended, they'd get paid the right amount. Helping to manage wasn't as hard after picking and harvesting, and we got to run the crew. Even the bosses and the farmers couldn't believe it. "Gee," they'd say, "these girls, they're so good at it." They couldn't believe that we were so young and women could do those things. The men we supervised were good to us. I mean they'd listen to us if we told

them we wanted them to do something and do it right. They wouldn't give us a hassle or anything. As a contractor, my dad would get a percentage of what the men earned—by the hour or by the bucket or the basket. The bosses or the farmers would pay my dad a certain amount, and from that, he would pay the workers. We had their time cards all marked, the hours or whatever they made from the buckets or baskets, and then we'd pay each of them their money. It was pretty good money for my dad and our family. Of course, Mary and I still had to be out in that hot sun.

I was eight years old before I started going to school. It was hard to go to school because we moved around so much. A lot of the bosses at the farms always asked my dad, "How come you have these girls working so hard? They should be going to school." But we couldn't go to school because there were so many of us, and we needed to help the family. When we were the oldest we had to work. Fortunately, my younger siblings didn't have to be out working in the fields like we did. They all went to school—at least they finished high school. And they got better jobs than we did. I started school when we lived in the Salinas Valley, and I went there for only two years. When we first arrived there, though, my mother hadn't signed us up yet. So one day, I was pumping water from the well about 500 yards from our shack and getting ready to carry it back, when I heard a voice, "Little girl, what are you doing here? Aren't you going to school?" I looked up, and I could see this truant officer, at least I assumed that's what he was; I was only eight years old. You should have seen me; I threw the bucket and ran. I think he looked to see where I was going. Pretty soon, we heard a knock on the door, and it was the truant officer. He introduced himself and said, "I saw your little daughter running. How come she's not going to school?" My mother said, "Because we've just got here." "Well, you're going to send her to school," he said, "and she better go to school."

But there was another reason why we weren't going to school. My sister and I had caught something like sores on our heads from the sprays on the plants in the fields and orchards. So when my mother took us to the doctor, he shaved us. Then my parents had to shave our hair again and again in order for our heads to heal. We were embarrassed to be out with no hair—baldheaded. So my mom said, "The reason I'm not sending them to school is because they don't want to go." Then she took off our caps. But he said we could go to school like that. We went, but they used to tease us a lot. They didn't call us names or anything, but they would tease us. "How come you're wearing those funny hats?" And of course we didn't want to take our caps off. We didn't want them to see our baldheads and all those sores. Within a couple of years, we were cured from our sores; our hair was grown. My grandfather thought that if we went underneath the cows while they made their number two, it would make our hair grow. The number two would be falling on our heads and then my mother would rub it in good. Then she would bathe us and clean us up. Today, look at our hair. My sister and I have very thick hair. Maybe it was true. I don't know.

When I went to school in Salinas, off and on for three years because we were coming and going, we were separated with the native Mexicans and blacks. Our skin was darker, and we weren't colored, but we were treated the same way. In school they called us "Mexican grease," grease because they said our skin was too greasy. I don't remember if it was the teachers or someone else at school, but everyday, they used to look underneath our fingernails to see if they were clean. Or they'd look into our ears to see if they were clean and if we'd bathed, and on our hair to see if we had lice. The white students weren't bothered; only we were. When we went to the movies and restaurants, we had to be separated from white people; we couldn't go

into certain areas. I had some cousins who were real fair-skinned and could pass for white. When we went out with them, we couldn't sit together.

During the winters, when we weren't working, the whole family would get together. Sometimes we went to San Jose. When we were younger, the only things we did was play or go walking. We had one bike, and there were about eight of us girls, between the sisters and the cousins, so we'd take turns. It was an old fashioned two-wheeler that seemed like it had just come out on the market. We visited family a lot and played cards together; we entertained each other.

They had these places where you could go dancing—we loved dancing—but my mother was very strict, and she didn't let us go out with our cousins. The only place we'd go to was the movies. By then, we were young teenagers. The boys were already looking at us, but my parents didn't go for that. Sometimes, though, my aunts and grandmother would let us go to the dances because they knew how strict my mother was with us. With all my girl cousins, there were about 13 of us more or less the same age. So all 13 of us would pile into one car every weekend and go to the dances.

One time we were coming in the car from one of my cousins' houses, and these sailors passed us in their vehicle; we were about 18 at the time. One of my cousins— she was a little devil and very pretty—whistled at them. That was the worst mistake she could have done. Now they started following us, and one of my other cousins was very scared. So she kept driving all over trying to get out of their way. Finally these sailors blocked us in the street. There were six of them, and they said, "How come you girls are trying to avoid us?" We said, "Because we're afraid." "Why did you whistle at us?" I said, "We didn't; my cousin did." They said, "We're not trying to do anything. We just thought we could go to the movies with you or something." We told them we're not going to the movies but to a dance. "What dance are you going to?" So we told them. We'd been at the dance maybe about half an hour, and here they come in. So we danced, and we talked to them, and the next day, they asked us for our addresses, but we didn't think that they would come to our house.

But Sunday there they were knocking on the door. I think I went and looked and I saw them at the door. I said to myself, "Oh my gosh, if my mother sees these boys— what are we gonna do? She's really going to be mad at us." I told them, "You weren't supposed to come to our house. We gave you our addresses because we thought you were going to write to us." "No," they said. "We thought we'd come and see you." My mother was out in the kitchen, so she didn't hear them knock, and we didn't have a doorbell. I said, "Go over there to the store on the corner, and we'll meet you over there because my mother is very strict. If she sees you here, she's gonna get real mad." So that's what we did. We asked my mother after a while, "Mom, could we go to the store?" "What do you want to go to the store for?" "Oh we're going to get something that we need." "Well, okay, but don't stay too long." For a long time they wrote to us. But then, after a while, we didn't hear from them, and we didn't know whether it was because they were in the Navy, whether they found somebody else, or whether they had died.

My dad decided to buy a home in Hayward in 1946; it was actually three houses away from the house my husband and I have lived in for nearly 50 years. He wanted to buy it so we'd have a place of our own to return to after we'd go do the crops. Then, during the winters, we'd have a place to stay as well. The 11-room house was white with yellow trim, had two bedrooms, a bathroom, running water, a sink, and a wooden stove. It had a foundation that was very low to the ground. We bought a washing machine, and after the clothes were rinsed out, we'd hang them out to dry.

I shared a bedroom with Mary. The room was medium sized, and we also shared a regular bed. We did have a new dresser. We even shared clothes because we used to fit in the same sizes. My parents couldn't afford to buy us dolls, so we'd cut out the dolls that came in the paper, and we'd play with them. But we'd cut them out of cardboard or paper, and we made believe that they were real. We really enjoyed it because we didn't know anything else. But I guess that's why up to now, I really like dolls, teddy bears, and all items like them.

We had pictures on the walls of movie stars. Frank Sinatra was our idol at that time. We listened to the music of Jimmy Dorsey, the bandleader, and Glen Miller. And then we had a radio, and I always listened to the news. It was a tiny radio. A couple of years later, our neighbors, an older couple from Oklahoma, would invite us over to use their television. At first, my mother didn't want to let us go. But the couple insisted, so we'd go over. They'd always give us cookies, and they were real nice to us. Even though they were an older couple (to us as teenagers), they were real sweet. I guess they figured, poor girls, they don't have any television. So we'd go over there and watch it for maybe a couple of hours, and then we'd come home. I remember we used to like *Zorro, Tarzan,* and *I Love Lucy.*

We still moved around, especially down to Salinas, where so many of the crops were. In 1948 I was working in a camp in Salinas that was run by my aunt and uncle, and that's where I met my husband. I was working in the kitchen and helping them cook for all the workers. I'd make 850 tortillas in the morning and 850 tortillas at night. When the men came in for breakfast, we also gave them eggs, potatoes, and coffee. My aunt served them real good food. There were 128 men, and they would eat their tortillas with beans or potatoes. All that cooking was hard work, but we were inside and not out in the sun. I helped out with all the work that was needed in the kitchen, and we had to get up at four in the morning to do it all.

I worked with my aunt and uncle for a while until my mother wanted me to move back to Hayward to help my father, who'd started being a labor contractor again. I was the oldest at home, so my father depended on me. Anyway, one day Ciro just showed up at our house. I'd given him my address, but he didn't like to write; he just likes to be right there. I had to tell my mother that this boy wanted to see me. She didn't really like that he was from Mexico. She was from Mexico, but she was only four years old when she left. During World War II she used to hear of the men who went from here to other countries and would leave the girls pregnant, and they wouldn't marry them, and they'd come back by themselves. Well, supposedly *Braceros* did the same thing. She thought because he was from Mexico maybe he would marry me, make me a child, and take off, or he was already married over there, and he wouldn't marry me.

My dad took it real hard. He didn't want me to marry. He said, "My daughter's not going to help me no more. What am I gonna do?" My younger sister used to help but she wasn't like me. I was better at it, I guess, since I was older; I took an interest in helping with the work. And my sister never really did. She didn't want to work that hard. She used to say, "Why do I have to work so hard?" She did it because she had to but not because she wanted to. So my father took it hard. He took off, and he was crying. My sister, Mary, she started crying, too. She didn't want me to marry because she wasn't going to have a sister to be with.

Ciro and I did go out three times to the movies here in Hayward, but he was fast at the relationship. He said, "If you don't marry me, that's it. I'm not going to come and see you no more." And I guess I figured, well, if I don't marry him, maybe I'm

not going to marry nobody. That's what I thought. But I did like him. At the beginning of our relationship, when he used to tease me, that's when I didn't really like him. When we went out, we would just hold hands because, I said, "If somebody sees me here that knows me and tells my mother, then I'm in trouble." My mother was so strict. I don't know why, because she was only 15 when she got married. So I told him, "All right, I'll marry you, but you have to ask my dad and my mom." So he came again after that and asked for my hand. He thought, since they didn't like him, that they were going to tell us to wait six months. My mom said, "If she wants to get married, fine." So right away Ciro said, "Before your mother changes her mind, I know we have to go get a blood test to find out if there's anything wrong with us." Three days after that, we got married by the justice of the peace over here in Hayward.

I didn't know that Ciro didn't have a job. They had laid him off right before the wedding, but he gave me money to buy my clothes. I bought a very pretty navy blue suit with a pink blouse, navy blue shoes, and my bonnet was pink. On the day of the ceremony, Ciro was coming from San Francisco, and there was a certain time that he was supposed to be there. Everyone in the judge's office kept teasing me that the bridegroom has changed his mind. He's not going to come, they said. And I was getting kind of nervous. I said, "Maybe that's true." He got there about half an hour late. He came with the couple that was to be the witnesses, and they had had a flat tire. My family was upset with us for getting married, so they weren't at the ceremony. Only my aunt and uncle from Salinas came to the wedding. My husband's friends that were from Mexico, they all chipped in to buy the liquor. They got some stuffed turkeys. They bought everything, all the food, so that we could have a little reception. We did have the reception at my parents' house.

At the beginning of our marriage, life was a little bit hard. He got laid off and didn't tell me. We didn't have a car, and we were living in a house my father helped us purchase. Our friends, the ones who were witnesses at the wedding, lived in San Francisco and had a car and a store. They were a really nice couple. They told my husband that if we needed anything, they'd let us have whatever we wanted, and we could pay them back when he got a job. We did take them up on their offer a few times before Ciro landed a job in Oakland and was there for 32 years. But even with the job, we struggled to make ends meet. At first, the house only had one bedroom, a living room, a little kitchen, and the toilet. Everyone—Ciro and me and, by 1959, four kids—slept in the same room. Not in the same bed. There was a couch, and one bed I turned into a bunk bed for the two boys.

In 1953 I did go to work in Hunt's Cannery in Hayward. I worked part-time on the late shift and made 35 to 40 dollars a week. These conveyors used to come by really fast, and you had to sort out the fruit, taking out the little ones and just leaving the big ones. The little ones you'd throw in boxes. Just left the big ones if they weren't rotten or spotted. I did this before the fruit was canned. Since I was a good worker, they didn't leave me for too long in one place, which made the work real hard. But I was working nights. When Ciro would leave in the morning for work, I arrived home to be with the kids. Ciro took care of the two kids we had by then at night. I made pretty good money because they used to pay you piece work at that time. You were paid for the amount of work you did. Later, I helped manage Los Compadres Restaurant in Hayward. I wasn't working that hard, but I had to be on my feet a lot. I hired people, fired them, paid them. I did some of the bookwork, and I took orders from the customers. I worked there about 12 years, until 1977.

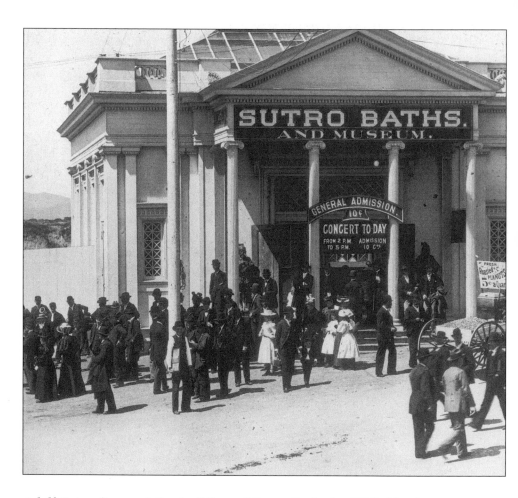

Adolf Sutro financed the building of Sutro Baths in 1896. The 3-acre spa was modeled after the baths of imperial Rome, with six saltwater swimming pools heated to different temperatures underneath a colored glass roof. A fire destroyed the baths in 1966. (Courtesy of the Photo Collection of the Golden Gate National Recreation Area, National Park Service.)

San Francisco families flocked to the beach at Sutro Baths because it was very accessible by streetcar. (Courtesy of the Photo Collection of the Golden Gate National Recreation Area, National Park Service.)

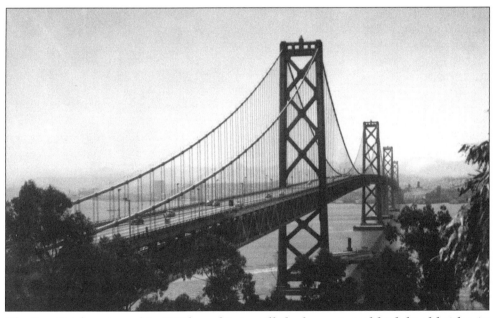

The Bay Bridge opened in 1936, and it is still the longest steel high-level bridge in the world. The 8-mile span, which links San Francisco to Oakland and the rest of the East Bay, is actually two bridges separated by a tunnel through Yerba Buena Island. The foundations of one of the piers are 242 feet below water, the deepest of any bridge ever constructed. The pier is bigger than any of the world's pyramids and needed more concrete than the Empire State Building in Manhattan. (Courtesy of The Anne Thompson Kent California Room, Marin County Library.)

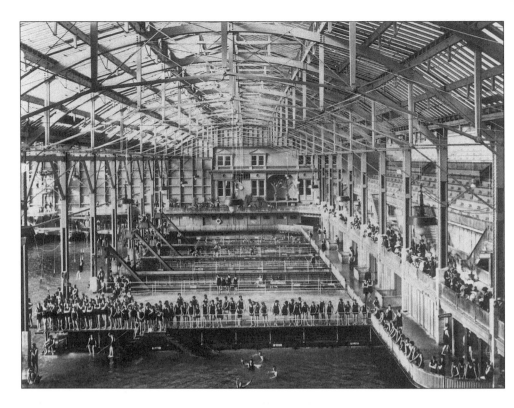

This is an interior view of the Sutro Baths in the 1920s. (Courtesy of the Photo Collection of the Golden Gate National Recreation Area, National Park Service.)

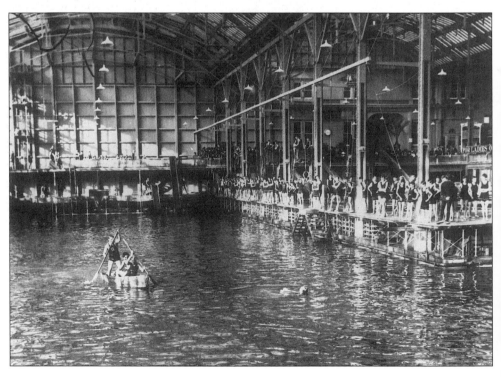

The ice skating rink was a popular attraction at Sutro Baths. (Courtesy of the Photo Collection of the Golden Gate National Recreation Area, National Park Service.)

The Financial District is often referred to as the "Wall Street of the West." San Francisco did not truly prosper immediately after the Gold Rush, but rather, it was the silver strikes in Nevada that made the city the financial center of the West. (Courtesy of the San Francisco History Center, San Francisco Public Library.)

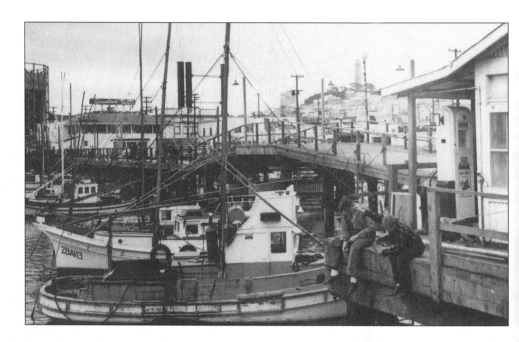

Tourism has replaced the commercial fishing industry as the biggest draw to Fisherman's Wharf. Souvenir shops dominate the wharf, once known as the hub of San Francisco's commercial fishing fleet. Seafood restaurants occupy the places where crab fishers used to haul in their catch. (Courtesy of The Anne Thompson Kent California Room, Marin County Library.)

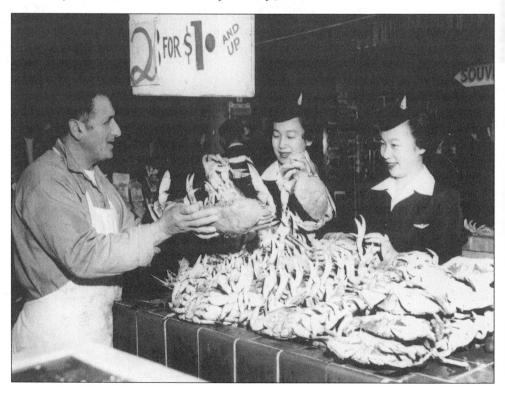

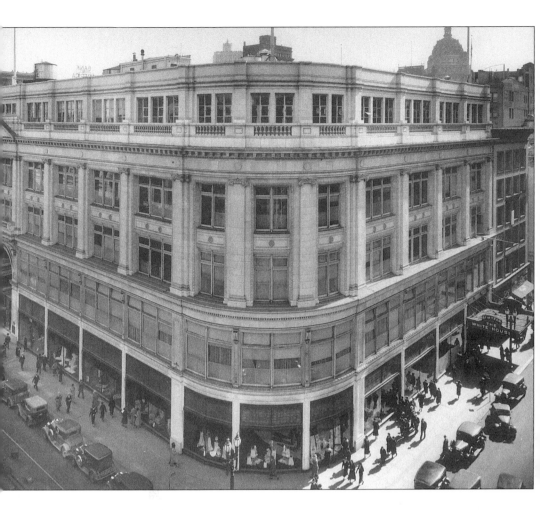

One of the more popular shopping spots was the White House department store, located near Stockton and Grant Streets. (Courtesy of the San Francisco History Center, San Francisco Public Library.)

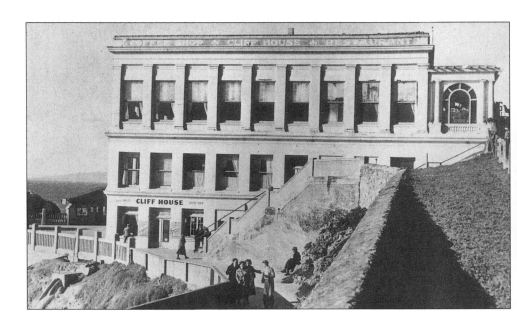

The fifth and last Cliff House opened in 1909, but today, little remains of the original building atop the rocks overlooking the Pacific Ocean. Remodeling and repair have altered its original design. (Courtesy of the Photo Collection of the Golden Gate National Recreation Area, National Park Service.)

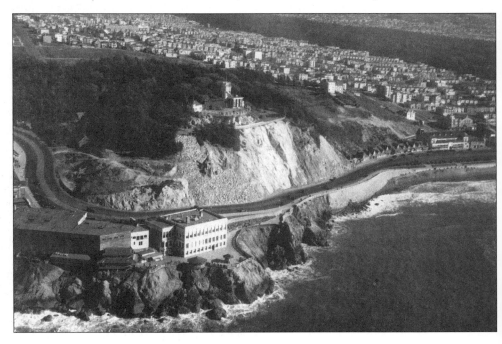

Sutro Baths (on the lower left corner) and the Cliff House provided not only recreation and relaxation for San Franciscans and others, but gorgeous views of the Pacific coastline as well. (Courtesy of the Photo Collection of the Golden Gate National Recreation Area, National Park Service.)

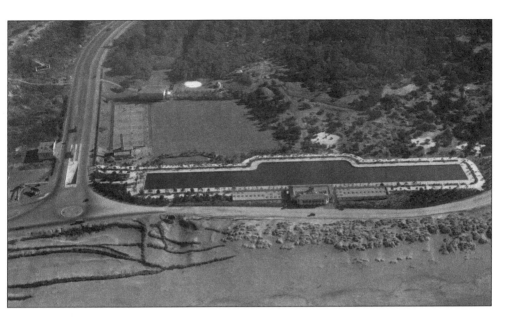

Fleishacker Pool, San Francisco's largest municipal pool, was a popular recreation spot from April 1925 to July 1971. Located at the end of Sloat Boulevard, the pool contained 6.5 million gallons of warmed salt water, pumped in from the Pacific Ocean, and was 1000 feet long and 150 feet wide. This photo was taken seven months after the pool opened. (Courtesy of the Photo Collection of the Golden Gate National Recreation Area, National Park Service.)

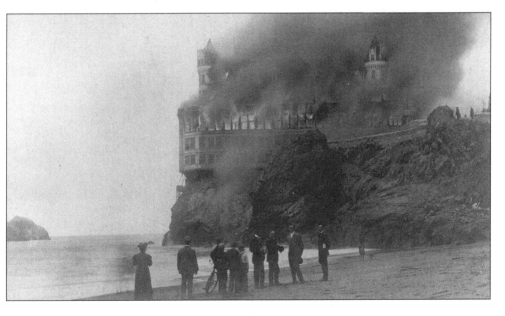

Sutro's Cliff House succumbed to fire in 1907. (Courtesy of the Photo Collection of the Golden Gate National Recreation Area, National Park Service.)

I hope this book will spur many of you to delve into your own family or community's oral history. There are plenty of excellent resources available to guide you on this journey, but I have found the following particularly useful:

1.　The Association of Personal Historians, of which I am a proud member, provides a directory of people who preserve personal history throughout the country. Their website (www.personalhistorians.org) has other valuable information.

2.　*LifeStory Magazine* edited by Charley and June Kempthorne. Their magazine is a "writer's workshop for autobiographers, memoirists, journalers, family historians, and other historians of everyday life." Charley has also written a wonderful book about putting those memories into words, *For All Time*. They can be reached at 3591 Letter Rock Rd., Manhattan, KS 66502-9317. 1-800-685-7330. http://www.kansas.net/~lifestor/>

3.　*To Our Children's Children,* by Bob Greene and D.G. Fulford. This must-have book, published in 1992, is filled with more than one hundred questions that will pry memories loose on a myriad of topics.

4.　Another website that has literally hundreds of links and resources for family and personal historians is from Nancy Pengra at the Center for Life Stories Preservation, www.storypreservation.com.

Please contact me for further assistance. My email address is st8runner@hotmail.com

I used the following books for the historical information in the various photographs from San Francisco:

Wurman, Richard Saul. *Access San Francisco*. Pennsylvania: Access Press, 1997.

Richards, Rand. *Historic San Francisco*. San Francisco: Heritage House Publishers, 1991.

Time Out Guide: San Francisco, edited by Time Out Magazine Ltd. England: Penguin Books, 1998.